PHOTOGRAPHIC
LENSES

PHOTOGRAPHER'S GUIDE TO CHARACTERISTICS, QUALITY, USE AND DESIGN

Ernst Wildi

AMHERST MEDIA, INC. ■ BUFFALO, NY

Published by:
Amherst Media, Inc.
P.O. Box 586
Buffalo, N.Y. 14226
Fax: 716-874-4508
www.AmherstMedia.com

Publisher: Craig Alesse
Senior Editor/Production Manager: Michelle Perkins
Assistant Editor: Barbara A. Lynch-Johnt

ISBN: 1-58428-058-1
Library of Congress Card Catalog Number: 00 135832

Printed in Korea.
10 9 8 7 6 5 4 3 2 1

Notice of Disclaimer: The information contained in this book is based on the author's experience and opinions. The author and publisher will not be held liable for the use or misuse of the information in this book.

TABLE OF CONTENTS

INTRODUCTION

Whether you work with film or in digital photography, with movie or video cameras, the image in the camera is created by a lens. The lens, or selection of lenses, determines what you can do with a camera, and how easily the desired results can be achieved. To a great extent, lenses determine the quality of the image produced in any camera, and choosing a lens must be a major—perhaps the most important—consideration when selecting equipment for serious work.

An understanding of lenses and optics will help you create outstanding images. It will also help you to determine whether manufacturer's claims about their lenses are based on technical facts or are contrived advertising statements that are misleading and possibly incorrect.

The topics discussed in this book are not approached from a scientific point of view. I have kept the information user-friendly, limiting the text to information that will help photographers achieve high-quality images. In the first part, I introduce you to the optical terms, characteristics of lenses,

and the camera and lens controls that create the image in the camera. The second part covers in more detail the lens design and the many types of lenses available for photographic purposes so you can determine what lenses are best for your application. In the third part, I discuss how lenses create the image and how they affect and determine the image quality so you can make the right choice when selecting new or additional lenses for your camera. In the fourth part, you will learn

medium format with a Hasselblad camera. In cases where the caption mentions the focal length of the lens used for a particular picture, you can determine the focal length that will produce the same image on your camera/image format from the equivalent focal lengths chart found on page 14.

All panoramic images contained in this book were made with the Hasselblad XPan camera. Unless noted otherwise, all the lens design illustrations and the performance spec-

An understanding of lenses and optics will help you create outstanding images.

all the facts that you need to know to obtain the best possible image sharpness in any camera. Finally, the fifth section will help you select the right lens and lens settings to accomplish specific results and will help you use the lenses and lens controls to produce the most effective images.

While the information contained in this book covers all cameras and image formats, most of the pictures were made in the $2\frac{1}{4}$" (6cm x 6cm)

ification diagrams are based on camera lenses made by Carl Zeiss for Hasselblad and are reprinted here courtesy of Carl Zeiss, Oberkochen, Germany, and Victor Hasselblad AB, Goteborg, Sweden. Special thanks to Erland Pettersson, product manager at Victor Hasselblad AB and to Kornelius J. Fleischer, manager, Marketing and Applications, in the Camera Lens division of Carl Zeiss for their technical help on this project.

1

LENS CHARACTERISTICS

● ●

● Advertising Claims

Every camera and lens manufacturer seeks to emphasize the unique characteristics and features of their lenses. While the majority of these advertising claims are correct, many statements can be misleading and misunderstood by photographers. The information I've provided in this book will help you sift through these claims, allowing you to separate truth from fiction. I've compiled a list of statements made by manufactures that have actually appeared in advertisements or literature published by camera or lens manufacturers. The statements are followed by my comments.

"For the first time in the world, a tele-macro lens capable of achieving 1.33x magnification at 1.4 meters. . ." This statement refers to a 300mm lens on a 35mm camera. All 300mm lenses have the same magnification—1.33x on 35mm film at a 1.4 meter distance. If a lens does not focus that closely, use extension tubes. The real concern is the image quality the lens delivers.

"Our 2x extender doubles not only the focal length but also the macro mag-nification ratio and increases the photo-graphic possibilities. A breakthrough of the traditional tele-extender. . . " Since any 2x extender doubles the focal length of the lens, every 2x extender made by any company used on any camera also covers an area half in size and thus increases the magnification.

"The zoom ring from 70mm–150mm enables any of the 80 individual focal lengths to be selected for optimum creative possibilities." Any manually operated zoom lens offers not only eighty but an unlimited number of focal lengths within its zoom range.

"Lens offers bright error-free focusing. . ." I would love to have such a lens. Unfortunately, accurate focusing has nothing to do with lens design; using a larger aperture naturally offers a brighter focusing area on any SLR camera. If the camera has automatic focusing, the focusing precision is determined by the focusing system, not the lens.

"This lens can be used handheld without fear of blurring." Lenses equipped with image stabilizers can reduce the likelihood of image blur but, otherwise, image sharpness in handheld photography is not determined by the lens design but, rather, the focal length of the lens, the shutter speed, and the photographer's ability to hold the camera steady.

"The macro teleconverter does not require a depth of field scale." Whether a lens is used alone or in combination with a teleconverter, you must have a depth of field scale or chart in order to ascertain the depth of field range.

"This lens enables users to photo-graph close-ups without sacrificing depth of field." I wonder how this is possible since depth of field is determined by the area coverage and the lens aperture, not the lens design. All lenses have the same depth of field at a specific aperture when covering the same area on the same image format.

The information I've provided in this book will help you sift through these claims. . .

"The spherical ability of the apochromatic lens brings office buildings to life." If I were an architectural photographer, I would definitely buy this lens as I would like to bring life to many office buildings.

These statements should convince you that a knowledge of optics will help you determine what lenses, lens designs, and lens characteristics are necessary to achieve the desired results and which ones are strictly statements issued to sell the lenses.

Lenses for Film Photography and Digital Recording

The advantages of recording images digitally, such as the immediacy of the results and the possibilities for manipulation and distribution of the results are well recognized today—perhaps to such an extent that some of the benefits of working with film are often overlooked. With film you can select the ISO rating that is most appropriate for a photographic situation. While today's digital cameras are rated ISO 100 (perhaps up to ISO 400), films are available with ratings higher than ISO 1000. (Digital cameras will undoubtedly improve in this respect.) With traditional cameras, you can chose black and white or color film and select the type of film that produces the most desirable results, and the best colors for a particular subject and/or lighting situation. You can also store thousands of film images in a simple, inexpensive fashion.

Despite the differences in advantages/disadvantages we've noted between film and electronic recording, traditional film and digital cameras share a common ground: The purpose, use, and operation of lenses is identical on cameras made for film and digital recording. Therefore, the information in this book applies to either application unless otherwise noted.

I use the word "photography" throughout the book to refer to the use of both film cameras and digital cameras.

Lens Specifications

Every camera lens is engraved with the maximum aperture (f-stop number), focal length, and the lens name and/or manufacturer's name. The focal length is usually indicated in millimeters. (25.4mm equals one inch. A 50mm lens, therefore, has a two-inch focal length.)

Focal Length

Lenses are distinguished mainly by their focal length, the distance at which the lens forms an image of a subject when focused to infinity. For a single-element lens, this is the distance from the element to the image point.

On a compound lens consisting of several lens elements, such as all lenses on cameras for film or digital recording, the focal length is measured from the rear nodal point, which is the point where the rear principal plane (H′) intersects the optical axis. This plane can be anywhere within the physical dimension of the lens or outside of it. Since the focal length is engraved on every lens, there is no need for us to know the position of the principal plane, but it may be shown on some lens specification sheets. On digital cameras, the lens specifications frequently do not give the actual focal length or focal length range of the lens on the camera, but the focal lengths that are equivalent to those of a 35mm camera. The sheet may read "equivalent to 32mm–96mm."

The focal length is an optical characteristic built into the lens. The focal length can be changed only by moving some of the lens elements (as is done in a zoom lens) or by remov-

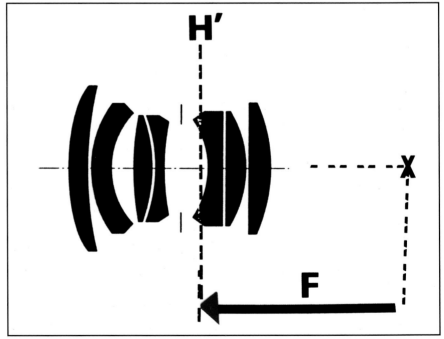

The focal length of a lens (F) is the distance between the rear principal plane (H′) and the point where the lens forms an image of a subject at infinity.

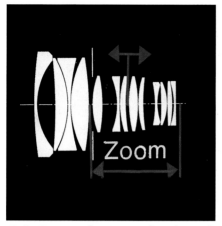

Left: An example of a zoom lens design showing the lens elements that are moved to change the focal length of the lens. Other elements are moved for focusing. Hasselblad 60 mm–120mm zoom lens. Middle and Right: A zoom lens makes it convenient to record a smaller or larger area of a subject without moving the camera or changing the lens. On the Apache trail in Arizona.

ing or adding lens elements. The latter happens, for example, when combining a lens with a teleconverter. It also happens when attaching a close-up (Proxar) lens; in this case, however, the change in focal length is so small that it need not be considered for photographic purposes. Close-up (Proxar) lenses are used for photography below the minimum focusing distance of the lens, not for changing the focal length of the lens. When working with a zoom lens, the focal length changes as the lens elements are moved.

The focal length of a lens remains the same whether the lens is used on a camera, an enlarger, or a projector. The focal length of a lens is unchanged by adding extension tubes or bellows, by switching a lens from one camera to another, or by using one and the same lens for photographing on different film formats. For example, a 150mm lens remains a 150mm lens whether it's used on a 4" x 5" large format camera, a 6cm x 6cm medium format or a 35mm camera.

● **Zoom Lenses**

As mentioned previously, the focal length of a zoom lens is changed by moving some of the internal lens elements. The ratio between the shortest and longest focal length is called the zoom range and is 2:1 or 2x for a zoom lens with a 60mm–120mm range, as might be the case for a zoom lens for a medium format camera. The zoom range is 3:1 or 3x for a lens with a focal length range of 35mm–105mm or 70mm–210mm.

The zoom range remains the same no matter how or where the lens is used. When a zoom lens is set to a specific focal length, it creates an image that is identical to one created by a fixed focal length lens of the same focal length on the same film format. Using a 35mm–105mm zoom lens set at 50mm on a 35mm camera, for example, yields an image identical to one created by the same camera with a 50mm lens.

Zoom lenses may maintain the same maximum aperture throughout the entire zoom range, or may have a slightly reduced maximum aperture at one end of the range, usually at the longer focal lengths. This is especially true with lenses with a longer zoom range (this feature may have been designed to simplify the design or

reduce the physical size of the lens). The reduced f-stop number of these variable aperture lenses is usually indicated with smaller numbers behind the maximum aperture. The designation may read f/3.5 in large print and f/4.8 in small print. While the change and reduction in the aperture may not be a serious drawback in general photography, most professional photographers select constant aperture lenses perhaps assuming that such lenses also deliver better image quality. This may or may not be the case depending on the make and type of lens.

On many zoom lenses, focusing and zooming is accomplished with the same control—zooming by moving the control back and forth, focusing by turning the control. This function is indicated with names like "integrated focus/zoom," "single-action focus/zoom," "one-touch zoom," and "push/pull zoom and focus." This combined control offers the fastest and simplest way to operate the lens, but the focus may be affected when zooming. On other lenses, the zoom and focusing motion are accomplished with two separate rotatable controls, which may be preferable for

many photographic applications, especially when you want to photograph the same subject at different focal length settings. The zoom motion may also be motorized and may be combined with automatic focusing.

When investing in a zoom lens for a camera, be sure to select what is known as an optically true zoom, a lens that does not need to be refocused when the focal length is changed. Most zoom lenses made for better cameras are of this type. Though the image stays in focus when using this type of lens, you can expect a critically sharp image only if the zoom lens is focused critically.

With high quality zoom lenses that have no focus shift, focus with the lens set at the longest focal length, regardless of the focal length that is actually used. At the longest focal length, the image has the greatest magnification, the depth of field is minimal, and focusing is most accurate. Lower quality zoom lenses, especially lenses with a long zoom range, often have what is known as a focus shift. That means that the lens designer was not too concerned about maintaining focus at every focal length perhaps because the lens may be used mainly or only on auto focus. The lens designer's main concern also may have been to come up with a lens that produces maximum image quality mainly at the shortest and longest focal lengths, the settings that seem to be used by most photographers. With such a lens, do the visual focusing with the lens set at the focal length that you plan to use for the picture. Zoom lenses on projectors often need refocusing when zooming, but this is not a disadvantage in this application.

The Operational Advantages of Zoom Lenses. A zoom lens reduces or eliminates the need to change lenses since it covers any focal length within its zoom range, providing practically unlimited control over composition. For example, a 28mm to 105mm zoom can take the place of a standard, wide-angle, and short telephoto lens on a 35mm camera. Lens changes are time-consuming, especially when each lens needs to be set to the correct aperture, shutter speed, and distance.

The focal length on a zoom lens can be changed without disruption of the other lens settings. You are always ready to shoot; you can take a long shot followed almost instantly by a closer view. All images made with a zoom lens at any focal length have the same color rendition. Zooms are helpful for work with TV and video cameras as they allow going from a long shot to a close-up (or vice versa) without stopping the camera and interrupting the action. In spite of this advantage, fixed focal length lenses are still extensively used in film production, feature films, TV commercials, and industrial films.

Disadvantages of Zoom Lenses. While a zoom lens appears to be a logical choice for any camera, it should not be the final choice without consideration of all the facts. Zoom lenses are physically larger than fixed focal length lenses. The length of the lens and the diameter of the front element are directly related to the zoom range, or determined by the shortest or longest focal length, depending on the optical lens design. The size and weight of zoom lenses must be considered—especially if the zoom lens is used as an all-around tool. The size and weight of a zoom lens is an especially "weighty" concern in use with medium format cameras.

The maximum aperture for zoom lenses is generally f/3.5 for 35mm and f/4 or smaller for medium format cameras. While these relatively small apertures may not be a serious drawback at the longer focal lengths, they are considered small when working at a shorter focal length, compared to the f/1.4 or larger aperture found on fixed focal length lenses on 35mm cameras, or f/2 on medium format

Lower quality zoom lenses often have what is known as focus shift. . .

cameras. When shopping for a zoom lens, you must also ensure that the focusing range of the zoom is acceptable for your intended use.

● **Focal Length and Image Format**

While the focal length of a lens remains the same when used on any image format, the relationship between the focal length and image format determines the area coverage and whether that particular lens is considered a standard, wide-angle, or telephoto lens when used on your camera.

To classify lenses as standard, wide-angle, or telephoto, you must consider the focal length in relation to the format. For most image formats, a lens is considered standard when its focal length is about equal to the diagonal of the picture format for which it is used. A 50mm lens is considered

Left: For general photography, I prefer a lens that is slightly longer than normal, 100mm–120mm on my 6cm x 6cm camera (the equivalent of about 65mm–80mm on the 35mm format). *Right:* Longer focal length lenses are great for closer views of subjects that cannot be approached (like this coastal scene in Ireland). More often, they should be used to eliminate unnecessary details and simplify the composition down to a single main subject.

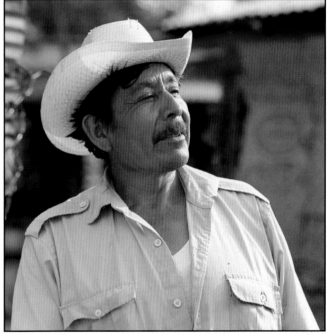

Left: Wide-angle lenses are ideal to enhance the feeling of depth. Foreground subjects are needed to accomplish this goal. *Right:* A good focal length for candid or posed people pictures is 110mm–150mm on a 6cm x 6cm camera (about 70mm–90mm on 35mm). It is long enough to create a pleasing perspective and background blur, and short enough to allow for the convenience of handheld photography.

standard on a 35mm camera, because the diagonal of the 24mm x 36mm format is about 43mm. 80mm is a normal focal length on a 6cm x 6cm medium format camera because the diagonal of the 2¼" (6cm x 6cm) square is 78mm. An 80mm lens is considered a short telephoto in the 35mm format, but a wide-angle on a 4" x 5". large format camera. Lenses with longer than standard focal lengths are classified as long focal length lenses, telephotos, or tele lenses. Lenses with shorter than standard focal lengths are considered wide-angle lenses.

The approximate lengths of the diagonals for various image formats can be found in the chart to the right. You can also determine the equivalent focal lengths for different image formats by referencing the equivalent focal lengths chart. This will help you determine which lenses produce identical area coverage on different cameras. This is especially helpful when switching from one format to another.

While the information we've just covered applies to large format cameras, the desired focal length is often determined by other factors. For example, a lens with a focal length that is 1.4x to 2x longer than the image diagonal is considered a good choice for product photography.

Focal Length for Movie/Video Cameras. The statement that a lens is considered standard when its focal length is equal to the image diagonal does not apply to motion picture cameras. In the motion picture field, a standard focal length is about twice the length of the diagonal. A 25mm focal length is considered standard for the 16mm format, which has an image diagonal of about 13mm.

Focal Length and Image Recording Area on Digital Cameras. The specifications provided by manufacturers of digital cameras seldom give the size of the actual image recording area (equivalent to the recording area on film, such as 24mm x 36mm for 35mm), but instead list the pixel resolution—such as 1280 pixels by 960 lines or simply stated as 1280 x 960. This is like specifying the resolution capability of the film in the camera instead of the film format. This specification is an important value in digital recording—it determines the image sharpness and probably also the price of the camera.

Lenses on digital cameras are usually engraved with their actual focal length like lenses on film cameras. The specification sheets for digital cameras, on the other hand, frequently do not show the actual focal length of the lens but, rather, list a focal length (or range of focal lengths) that covers the same area on a 35mm camera. The manufacturer's specification sheet may read "equivalent to 38mm–86mm," but the actual focal length may range from 8mm–18mm.

Approximate Lengths of Diagonals for Different Image Formats

Film Formats	APS (H)	.34mm
	APS (C)	.28mm
	APS (P)	.32mm
	35mm	.43mm
	6cm x 4.5cm	.68mm
	6cm x 6cm (2¼" square)	.78mm
	6cm x 7cm	.88mm
	4" x 5" large format	.150mm
Motion Picture	16mm	.13mm
	35mm	.27mm
Digital Formats		*see text*

Equivalent Focal Lengths for Different Image Formats

The table below lists the equivalent focal lengths (in mm) for the most popular image formats (based on the area coverage along the long side of the image).

35mm	6cm x 6cm 6cm x 4.5cm	6cm x 7cm	4" x 5" large format
15	22	28	50
17	25	32	57
20	31	38	67
28	43	54	93
33	50	63	109
50	76	96	170
65	100	125	220
88	135	170	300
135	200	260	450
200	300	380	670
300	460	570	1000
330	500	630	1100

This is a very logical approach since the size of the image recording area, the CCD (Charge-Coupled Device), or CMOS (Complementary Metal-Oxide Semiconductor), varies greatly among cameras, especially in point and shoot types. The specifications for one camera may indicate a lens with equivalent focal lengths from 36mm to 110mm, having an actual focal length range from 9.2mm to 28mm. Another camera may have a practically identical equivalent focal length range from 36 to 108mm, but the actual focal length range of the lens on the camera is only 6.5 to 19.5mm. The two cameras obviously have completely different sensor sizes.

The CCD (or CMOS) in professional cameras and digital backs for medium and large format cameras also varies, but is often about the size of a 35mm frame or slightly larger. If that is the case, on a medium format camera a 50mm lens (normally a wide-angle) becomes the standard focal length. Use the chart of equivalent focal lengths (previous page) to determine the lens needed for a particular application.

The specifications for digital cameras usually also include the storage format, such as 12MB, which determines the number of images that can be stored, somewhat like the number of images that can be recorded on a roll of film.

● **Angle of View**

The angle of view, as the name indicates, is the angle of the area the lens covers when it is used on a specific film format. The angle of view can be related either to the diagonal, horizontal, or vertical dimension of the

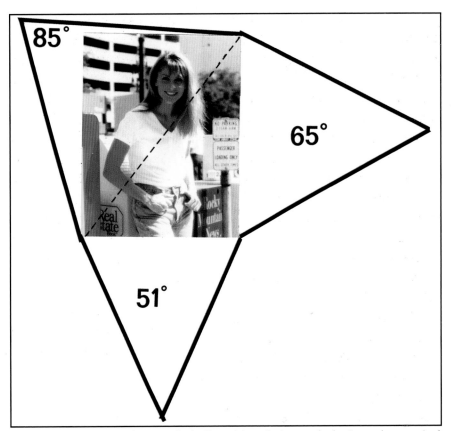

The angle of view of a lens can be indicated in relation to the horizontal or vertical image format or in relation to the image diagonal. The three can vary from 51° to 85° so you must know which figure a manufacturer uses in the specification sheets.

picture format, and can be indicated in either way on lens and camera specification sheets. Be sure that you understand what these figures mean.

On the 2¼" (6cm x 6cm) square format, where the vertical and horizontal lengths are equal, an 80mm lens has a horizontal or vertical angle of view of 38° and 52° diagonally. When used on a 4.5cm x 6cm format, the angle of view of the same lens is still 38° horizontally, but only 28° vertically and 46° diagonally. A 50mm lens on a 35mm camera has a diagonal angle of view of 46°, a 40° horizontal angle of view, and a 27° vertical angle of view.

Any lens that has a diagonal angle of approximately 50° is considered standard on any format except movie and video cameras.

● **Area Coverage**

The angle of view of a lens determines the area coverage and the magnification. The area coverage for any lens is directly proportional to the subject's distance from the lens. At twice the distance, a lens covers an area twice as wide; at half the distance, the lens covers an area half as wide. A lens with a larger angle of view covers a larger area from the same distance, which also means that the magnification is lower and the subject is recorded smaller.

Angle of View and Area Coverage in the APS Format. Cameras made for the APS (Advanced Photo System) format offer a choice of three different image formats, the classic type (C) producing a 16.7mm x 30.2mm image in the 2:3 ratio on the film, a wide-angle image (H) with a 9:16 ratio, and

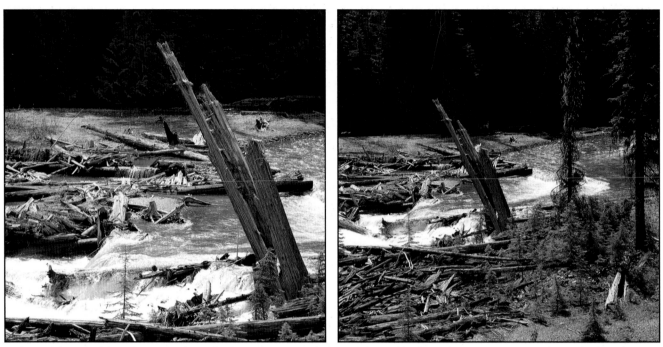

A lens with a focal length twice as long (left) covers an area half as wide and high on the same format and records the subject 2x larger than the shorter focal length (right). This photograph was taken in British Columbia.

Wide-angle lenses used from the same distance cover larger areas and record subjects smaller than standard focal length lenses. Telephotos cover smaller areas and magnify subjects.

The image recorded on the film in any of the three APS formats is identical. The C (top), H (middle), and P (bottom) print formats are obtained by printing from the same negative.

a panoramic image (P) with a 1:3 ratio. These different image sizes are not produced in the camera, but in printing. No matter which format is selected, the image on the film is always 16.7mm x 30.2mm. The classic and panoramic formats are obtained by printing only a portion of the negative, an area of about 23mm x 16.7mm for the classic and an area of about 10mm x 30.2mm for the panoramic size. The image diagonal for all three formats varies little—from about 28mm to 34mm. The same focal length lens can be considered standard for all three formats.

If you change your mind about the image format you've chosen, the APS lab can override the code on the film and print your photo in any of the other APS formats.

Angle of View and Area Coverage for Panoramic Cameras. When working with panoramic cameras (those that produce images with one dimension much longer than the other), it makes sense to consider the equivalent focal length that would cover the same area along the long side of the image in a standard image format.

For example, on the Hasselblad XPan camera, which is popular for producing panoramic images on standard 35mm film, the 45mm focal length lens (which is a normal focal length for the standard 35mm format of 24mm x 36mm), covers an area along the long side of the image that is equivalent to that of a 25mm lens on the standard 35mm format. To me, it makes sense to think of the 45mm lens as a 25mm wide-angle.

Looking at it in this way, the 90mm lens on the XPan produces panoramic pictures that look more like

a standard 50mm shot, while the 30mm lens produces pictures that are like 17mm wide-angle shots. The same logic can be applied to other panoramic cameras.

● Covering Power

Covering power is not the same as area coverage. Lenses are optically designed to produce satisfactory image quality and illumination for a specific image format. With 35mm lenses, this quality is delivered when used on the 24mm x 36mm format. Medium format lenses on a 6cm x 6cm function the same way on the 2¼" inch (6cm x 6cm) square format, but not necessarily on anything larger. This lens design characteristic is called covering power. The covering power depends on the design of the lens, not the focal length. Lenses with a 100mm focal length, for instance, can be made to cover the 35mm format, the 55mm x 55mm film area of the 6cm x 6cm medium format, or the larger area of a 4" x 5" camera. A lens made for a 24mm x 65mm panoramic camera must cover the 70mm diagonal area of this format, even though the image is produced on 35mm film. The lens must have the covering power necessary for the 6cm x 4.5cm medium format, which has the same image diagonal.

Since all lenses produce a circular image, the covering power of a lens can be indicated by the diameter of the circle within which definition and

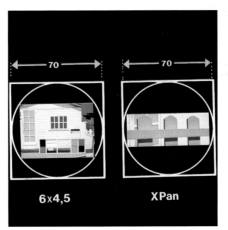
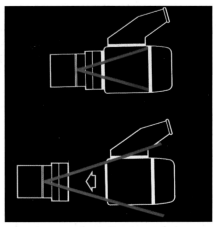

Left: *The covering power of a lens is the circle within which the lens produces satisfactory image sharpness and illumination. It must be at least equal to the diagonal of the image format for which the lens is used.* **Middle:** *Although a 24mm x 65mm panoramic format is created on 35mm film, the covering power of the lens must be equal to that of a 6cm x 4.5cm medium format camera as the two image diagonals are identical.* **Right:** *The covering power of a lens increases as the lens is moved away from the image plane by focusing, and in adding extension tubes or bellows. The difference can be drastic on a large format camera with the bellows extended for close-up work. Since the light is distributed over the larger area, the image area receives less light, requiring an increase in exposure.*

Wide-angle lenses, such as the Carl Zeiss Biogon used in this illustration, can have superb corner sharpness and illumination. But since wide-angle lenses generally have a greater falloff in corner sharpness and illumination, the lens specifications for covering power and illumination must be studied carefully.

Good covering power is also needed on lenses used on panoramic cameras since a darkening in the corners can be very objectionable in panoramic pictures. 45mm lens on an XPan camera.

illumination are satisfactory. Beyond that circle, the illumination or the sharpness (or both) are unacceptable. Lenses designed for a larger format can be used for a smaller format. Medium format lenses, for example, can be used on 35mm cameras if the necessary adapter is available.

● Image Circle

While the term "covering power" is frequently used in working with smaller formats, the term "image circle" is used to describe the same qualities when working with lenses designed for large format cameras, where bellows extensions are almost unlimited.

The size of the image circle that produces satisfactory image quality is smallest when the lens is focused at infinity. It increases at closer distances and is twice as large at 1:1 life-size magnification, and about 20% larger at a 1:5 magnification. The usable image area also becomes larger as the aperture is closed down. The darkening that may occur in the corners of extreme wide-angle lenses can be reduced by taking pictures at smaller apertures.

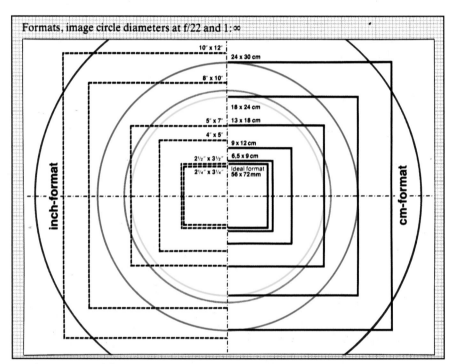

On large format lenses, covering power is usually referred to as the image circle, which also shows the amount of shift that is possible for a specific lens and image format. Chart courtesy of Rodenstock.

On large format cameras with swings and tilts, often called technical cameras, focal length and film format are not as directly related as on other cameras because the covering power of the lens may have to be determined by the necessary degree of shift and tilt required for a specific picture. The covering power of such lenses is usual-ly indicated on charts by circles super-imposed over the different film formats. These charts show how much of the lens or film plane can be shifted before the image goes beyond the usable image circle.

The covering power of perspective control (PC) lenses or PC teleconverters in combination with regular lenses

on 35mm or medium format cameras, must also be larger than the diagonal camera format to allow shifting and/or tilting the film or lens plane.

● The Lens Aperture

The lens aperture plays three roles in the image-forming process. It determines the amount of depth of field, influences the image quality—especially in the corners of the image—and, in combination with the selected shutter speed, determines the exposure.

The maximum lens aperture, indicated by an f-stop number, is engraved on every camera lens. A large opening, which allows more light to hit the film, is indicated by a small number, such as f/2.8; a small opening, which lets less light onto the film, is indicated by a higher number, such as f/16. These figures are somewhat contradictory because the f-stop number represents the ratio between the focal length of the lens and the diameter of the entrance pupil. For example, a 150mm lens may be engraved with the number f/4 because the entrance pupil is 37.5mm in diameter (4 x 37.5 = 150). The size of the entrance pupil is known only to the lens designer, but may be indicated on some lens specification sheets. The maximum aperture of a lens is frequently referred to as the "speed" of the lens, and lenses with large apertures are known as "fast" lenses.

It is helpful to note that aperture numbers are multiples of 1.41; for example: f/4 = f/2.8 x 1.41, f/16 = f/11 x 1.41. The factor is 1.41 because it is the square root of two. Light intensity increases or decreases in proportion to the square root of two. This applies to everything that has to do with light. If you want to double the brightness from a light source in the studio or a flash unit on the camera, move the light 1.41x (not 2x) closer to the subject. If you want half the amount of light on the film, increase the distance by 1.41x. The f-stop numbers work the same way: A change in aperture from one figure to the next either doubles or halves the amount of light reaching the image plane.

A diaphragm built into the lens allows for a reduction of the aperture from the maximum lens aperture to f/16, f/22, f/32 or even smaller, thus reducing the light that reaches the film. This operation may be automatic or manual, or the camera/lens combi-nation may offer the option to use it either way.

Lens diaphragm design varies, with some having more diaphragm blades—perhaps as many as eight—than others, which may only have five. There is no difference in the operation or the exposure accuracy. However, in images where a bright light source shines into the lens, the image of the diaphragm may become visible on the film. Some photographers feel that the almost-round shape of a diaphragm with more blades is nicer than one in which you can see the separate blades. This should be a minor consideration, however, since images with such reflections seldom occur in normal photography.

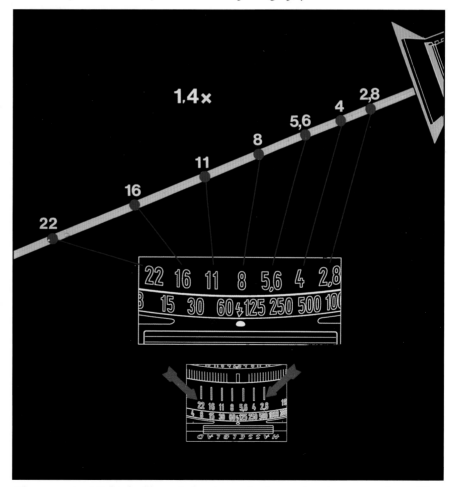

The amount of light doubles or halves in proportion to the square root of two. That applies to light, subject distances, and aperture values on a lens.

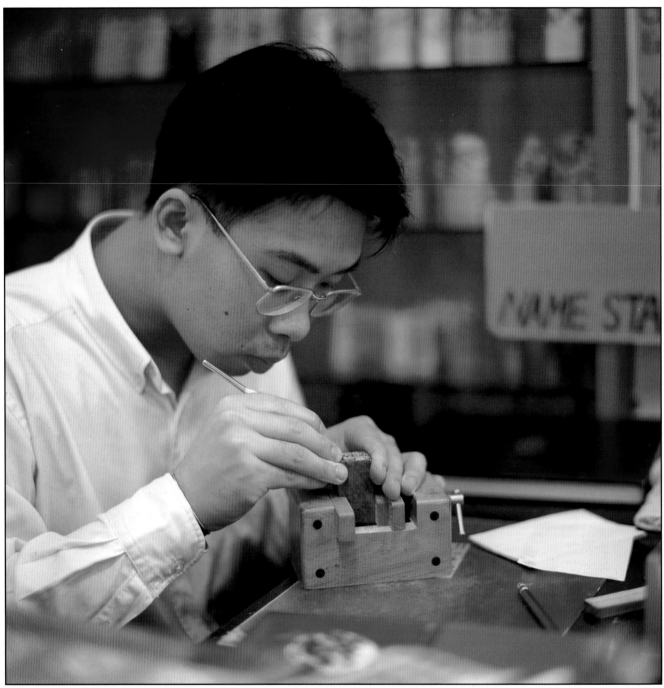

Large aperture lenses produce a brighter image on the SLR focusing screen and offer more possibilities in photographing in low light levels. A large aperture is especially helpful when it is necessary or desirable to work with handheld cameras, as was the case when photographing this Chinese craftsman in Hong Kong .

The maximum lens aperture also determines the brightness of the image on the focusing screen on an SLR or large format camera. You may also want to keep in mind that split-image rangefinders that are part of a focusing screen must usually be used at lens apertures of f/5.6 or larger to avoid split-image blackout. A similar requirement applies to microprism screens.

T-Numbers. Some lenses for professional motion picture cameras are engraved with aperture figures in T-numbers rather than f-stop numbers. T-numbers are based on the actual amount of light that reaches the film, taking the light that is lost due to reflection on the lens surfaces and by absorption in the glass into account. Any lens set to a given T-number produces exactly the same exposure regardless of the number of lens elements that specific lens contains.

T-numbers came into existence before multicoating where the light loss from light reflections on the lens surfaces could amount to 50% or more. Lenses with more lens elements transmit less light than lenses with fewer elements. With multicoating, the light loss is reduced on any lens to such an insignificant amount that we can assume lenses made by the same company and set to the same f-stop numbers produce the same exposure. T-numbers, therefore, do not offer the same advantages today that they did in the past, but they are still the preferred choice for motion pictures as they also take into account the light loss due to absorption in the glass. Furthermore, zoom lenses used on TV and video cameras allow the photographer to go from a long shot to a close-up or vice versa without switching lenses.

● Shutter and Shutter Speed

While shutters and shutter speeds are not necessarily lens characteristics, they work with the lens aperture in creating the image. Shutters can be built into a lens (leaf shutters or central shutters) and thus become part of the lens and lens operation, or they can be part of the camera body (focal plane shutter). In either case, the shutter controls the length of the exposure time and the shutter speed. Together with the lens aperture, it also determines the total amount of light that reaches the image plane. In regard to the image creating process, there is little difference between the shutters.

Lens Shutters. With lens shutters, the shortest shutter speed available is $^1/_{1000}$ second. Most, however, are limited to $^1/_{500}$ second. A lens shutter exposes the full image area at all times, allowing you to take flash pictures at all speeds up to $^1/_{500}$ second (or the shortest shutter speed available).

Since the lens shutter blades open from the center and close toward the center, one occasionally hears the comment that the image produced with such a shutter is brighter in the

Top: Because focal plane shutters scan the image area, a flash must fire when the shutter curtains are open over the entire image area (image #3, top). Lens shutters open from the center and close toward the center. A flash can be used at all shutter speeds but must fire when the shutter is fully open (image #3, bottom). Bottom: A lens shutter that can be used for flash at shutter speeds up to $^1/_{500}$ second is helpful, and sometimes necessary, in using flash for pictures taken outdoors in bright sunlight. This is especially true today when many wedding photographers work with ISO 400 films.

center than at the corners. This is not the case if the shutter (and the aperture) is positioned within the lens where light from any point of the subject also reaches any point in the image. This shutter and aperture placement assures that the edges of the image receive the same amount of light as the center (except for the common loss of light due to the optical or mechanical design of the lens).

Focal Plane Shutters. Focal plane shutters can provide much shorter shutter speeds, at present up to about $\frac{1}{12000}$ second. Since the focal plane shutter scans the image area, different areas of the film are exposed to light at different times. A flash must fire when the shutter curtain is open over the entire film area. This does not happen at high shutter speeds. As a result, flash sync shutter speeds are limited. This is no longer a serious drawback on 35mm cameras where

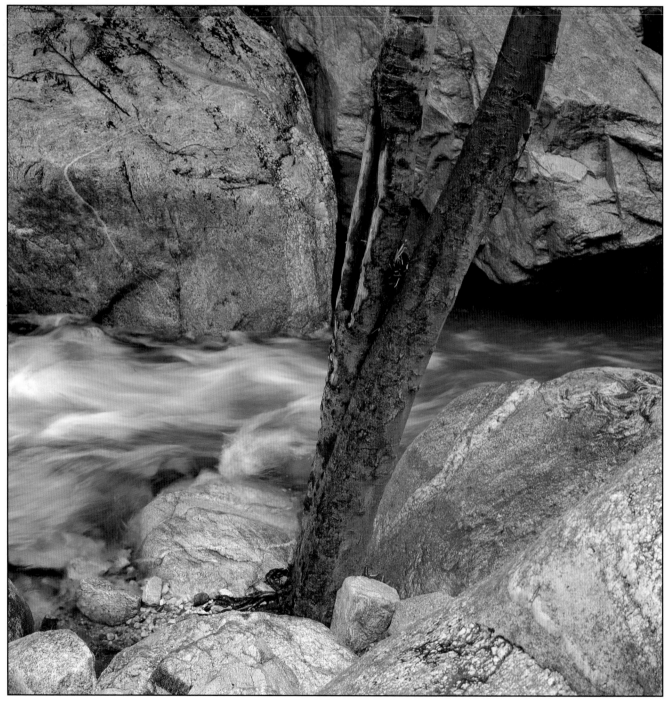

The blur in the stream, produced at a ¼ second shutter speed, contrasts beautifully with the sharp details in the rocks in the foreground.

flash sync is possible up to $^1/_{250}$ second. Focal plane shutter flash sync is more limited on medium format cameras since the shutter curtain has to travel much greater distances.

As a focal plane shutter scans the image area, a moving subject may become distorted, looking elongated when it moves in the same direction as the shutter curtain, or shorter when moving in the opposite direction.

● Exposure Values

A few lenses, mainly in the medium format, have an exposure value (EV) scale. Exposure values are single numbers that indicate how much light exists in a certain location based on the ISO that is set on the meter. If you have such lenses and a metering system that shows EV values, it is advantageous to work with this system for various reasons.

EV values are single numbers that are easier to remember and to transfer from the meter to the lens or from one lens to another. It is also easy to remember exposure values that are correct for a particular film in standard lighting conditions. For example, EV 14 is a good choice in sunlight for ISO 50 or ISO 64; EV 15 gives good exposure in the same light for ISO 100—at least on transparency film. The correct exposure is obtained regardless of the aperture/shutter speed combination that is used for the indicated EV value. For EV 14, for example, you can select an f/16 and $^1/_{60}$ second or f/8 and a $^1/_{250}$ second shutter speed.

Once the lens is set for the correct EV number, you can see all of the possible aperture and shutter speed combinations that provide the correct exposure by checking the engravings

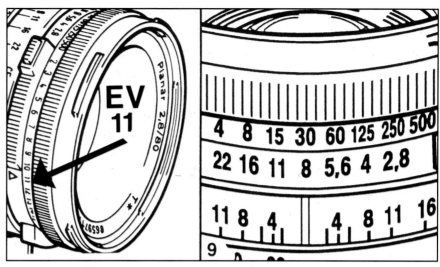

When a lens engraved with EV values is set at a specific EV value, such as EV 11, any of the aperture and shutter speed combinations shown will produce the same exposure.

on the lens. This is an easy and effective way to determine which aperture/shutter speed combination creates the most effective image.

● Focusing Control

Focusing is the last operating control that exists on all lenses or cameras—with the exception of the simplest point and shoot models. Focusing simply means moving the lens (or in some cases the image plane) to a point where a subject at a specific distance forms a sharp image on the image plane. The closer the subject to the camera, the further the lens must be moved from the image plane. In opti-

fication instead of, or in addition to, the distances.

Internal Focusing. In focusing, the entire lens is moved further from the image plane, usually making the entire lens physically shorter or longer. Long telephoto lenses often feature a design known as internal focusing, sometimes called integral rear focusing, where the distance setting is accomplished optically, without physically altering the length of the lens. This focusing method is an advantage in long telephotos, not only because it may reduce the physical size of the lens, but because focusing is usually easier and smoother.

In optical language, a shorter subject distance requires a longer image distance.

cal language, a shorter subject distance requires a longer image distance. A longer focal length lens must be moved further from the image plane for a specific subject distance than a lens of shorter focal length. On some lenses made specifically for close-up work, the focusing ring may have engravings showing the image magni-

Automatic Focusing. Focusing can be accomplished manually or automatically and, in most cases, a good automatic focusing system provides amazingly good results—as least for casual work. A camera equipped with automatic focusing may be considered for serious photography as long as it offers the option of manual focusing or, even

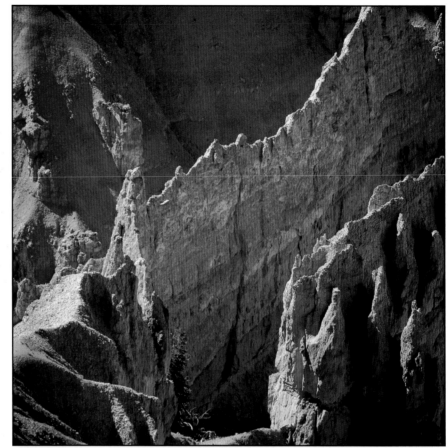

Above: On telephoto lenses with internal focusing, focusing is accomplished by moving some lens elements rather than moving the entire lens. Carl Zeiss 350mm Tele-Superachromat. **Right:** Internal focusing on the 500mm Carl Zeiss Tele-Apotessar made it easy to determine the minimum and maximum distances that should be sharp on these rock formations at Cedar Breaks National Monument. The lens was then set to the distance that produced the desired depth of field.

Because the area that needs to be sharp can be anywhere within the composition, an automatic focusing system must allow you to decide on which part of the subject or scene the lens must focus.

better, has a single focus mode that lets you focus at the part of the subject of your choice, then locks the focus so that you can recompose the image without a change in the focus setting. This is essential in serious photography since the photographer, not the camera, has to decide which part of the subject or scene the lens must be focused on. The automatic focusing feature is then simply used to turn the focusing ring instead of doing it manually. In many other situations, the focus setting is not based on a specific part of a subject but, instead, is based on the desired depth of field. The automatic focusing feature is then used to measure the minimum and maximum distances of the desired sharpness range. The final setting must be made manually.

In many scenes, the distance setting is based on the desired depth of field. An automatic focusing system is then simply used to measure the minimum and maximum distances that should be within the depth of field range. In this case, these are the distances to the closest green leaf at the bottom of the frame and to the furthest green leaf at the top of the frame.

With automatic focusing, a signal in the viewfinder may indicate when proper focus is achieved, and therefore offers great benefits for photographers having problems identifying on the focusing screen the point at which the lens is accurately focused. Utilizing the automatic focusing mode is also advantageous when there is no time for focusing—as in candid and street photography or with moving subjects, especially when they move toward or away from the camera. In such situations, you need the continuous focusing mode where the focus changes continually as the camera or the subject moves.

● Exposure at
Close Distance Settings

When a lens is focused at closer distances, the lens is actually moved further away from the image plane, causing a reduction in the amount of light reaching the image plane. The reduction is negligible for all practical purposes within the normal focusing range of a lens, as it practically never exceeds a half stop. If the change in the lens to image plane distance is more drastic, as is the case on a macro lens used at the macro setting, when using extension tubes or bellows on any camera, or when a large format camera is extended for close-up work, the light reduction must be considered when using a separate exposure meter. If you measure the light in the camera (TTL) the reduction is automatically taken into account.

● Macro Lenses

Some zoom or fixed focal length lenses, especially for 35mm cameras, are referred to as macro lenses. A macro

A general-purpose lens designed for maximum sharpness at close distances can produce superb image sharpness, even in life-size magnification and at large apertures. Image taken with Carl Zeiss Makro-Planar 135mm.

lens has a longer focusing range than an "ordinary" lens, allowing you to photograph closer without having to use close-up accessories. Such a lens can be advantageous if you plan to do much close-up work. But before investing in a macro lens, consider the other characteristics of the lens, the maximum and minimum apertures, its size and the image quality, keeping in mind that any non-macro lens can be used for close-up work in combination with close-up accessories such as

extension tubes. The use of these accessories does not necessarily complicate close-up photography. On a macro zoom lens, it is worthwhile to investigate whether the focusing is continuous all the way into the macro range, whether the lens can be used in the macro range at all focal lengths, or whether it needs to be set at a specific focal length for macro work.

Some lenses are called macro not because they focus closer but because they are optically designed to produce

the best image sharpness at closer distances. The Zeiss Makro-Planar is of this type.

All camera lenses are designed to produce the very best image quality at a specific distance or range of distances. Unless specifically indicated, we can assume that camera lenses provide the very best image quality at longer distances but also produce acceptable or even good quality at all distances within the focusing range of the lens. Large format camera lenses are usually designed for good image quality within a magnification range from 1:3 to infinity, but achieve the best quality at a magnification range that is typical for product and advertising photography.

Macro Lenses for Large Format Cameras. Macro lenses are also available for large format cameras. They are corrected to provide the best image sharpness within a magnification range from about 1:5 to 2:1, perhaps being optimized for a 1:2 magnification.

Reversing Lens. In photography at normal distances, we have a long subject distance in front of the lens and a short image distance between the lens and the image plane. Camera lenses are designed to produce the best image quality under those conditions. At 1:1 life-size magnification, the two distances are equal with the total distance between subject and image plane being 4x the focal length of the lens. When photographing larger than life-size, the distances are reversed, with the image distance becoming longer than the subject distance.

This optical fact prompted some lens manufacturers to offer lenses that can be mounted on the camera in the reversed fashion, with the rear toward the subject and the front toward the image plane. A lens used in this position can provide better quality in close-up photography, but only when the magnifications are larger than 1:1.

Special Lenses for Macro Photography. Photographic lenses,

Camera lenses are designed to produce the best image quality at a specific distance. . .

either the macro type or other lenses used with close-up accessories, can allow magnifications up to 1:1, covering an area of 24 x 36mm with 35mm cameras, and 6 to 7cm in the medium format. A few manufacturers, especially those that also manufacture other optical instruments, like microscopes, offer special macro photography lenses designed for magnifications from about 2x to 20x. Such lenses may look like objectives for a microscope and are equipped with the standard micro-

scope thread. They have an aperture but no focusing mount and are best used in combination with a bellows on the camera. The bellows then serves for focusing as well as for obtaining different magnifications by extending the bellows more or less. Needless to say, focusing is extremely critical as there is practically no depth of field.

When working with macro lenses, the amount of light that reaches the image area is greatly reduced, requiring long shutter speeds. The use of electronic flash is highly recommended for this type of photography. It not only produces more light, but the short flash duration eliminates camera motion problems. Exposure is best determined by a test shot—preferably with Polaroid film.

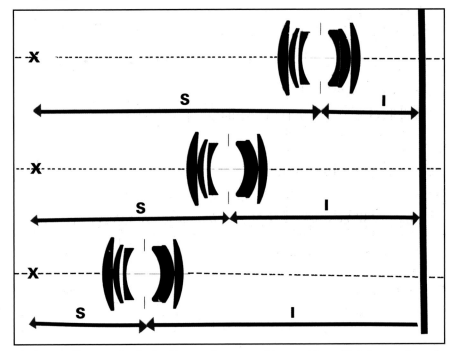

At longer distances (top), the distance between subject and lens (S) is longer than the distance between lens and image area (I). At life-size magnification, both distances are identical (center). When the magnification is more than life-size on any camera, the image distance becomes longer than the subject distance (bottom).

● Other Optical Lens Specifications

Manufacturers' lens specification sheets may also show the position of the front principal plane with the front nodal point. This can be helpful to a photographer producing panoramic pictures by rotating the camera and combining the images afterward. To keep the perspective constant, the camera should be rotated around the front principal plane. However, this requirement is not as important today because panoramic views from separate images can also be produced via the computer. Other specifications listed are the position of the entrance and exit pupil and the diameter of the exit pupil. They are of no importance to the photographer.

A special high magnification lens was used to photograph a small detail from a Swiss postage stamp with superb corner to corner sharpness and contrast.

2

LENS DESIGN

• •

The quality of a lens determines to a great degree the image quality produced in any camera. Learning the basics of lens design and manufacturing, lens types, and the image-creating characteristics of lenses will help you to equip your camera with the most suitable lenses for your type of photography, and will help you produce the ultimate image sharpness.

● **Computer Designs**

Some lens manufacturers claim that their lenses are superior due to the fact that they are computer designed. However, all lenses are computer designed and have been computer designed ever since computers came on the market. The computer, however, does not design the lens, but only traces the light rays of the different colors through the lens elements to determine the point at which they form the image. What comes out of the computer depends on the information put into the computer by the lens designer.

Claiming that a computer design makes a better lens becomes even more questionable when one realizes that the sharpness of any lens, made anywhere in the world, depends not only on the design but, to a larger degree, on the accuracy and precision in manufacturing and assembling the components.

Computer designed lenses can be developed much more quickly than lenses made in the past. Before the computer age, calculations now handled by computers had to be made manually. This was extremely time-consuming, and it frequently took years to come up with a new lens design.

● **Low-Dispersion Glass**

Another common claim for lens superiority is based on the use of new types of low-dispersion glass, sometimes also referred to as rare earth glass. Every manufacturer of quality lenses has a large number of glass types available. The lens designers at Carl Zeiss in Germany, for example, have more than 250 types to chose from—many of them of the low-dispersion type. All lens designers use these new glass types, even though the fact may go unmentioned in advertisements or literature.

Using rare glass does not automatically produce a better lens; the lens designer must decide whether the use of such glass is beneficial, or

Using rare glass does not automatically produce a better lens. . .

whether an equally good, or better quality can be obtained in other ways. The use of these modern glass types will result in a better lens only if the lens is manufactured and assembled to the highest standards.

● **Number of Lens Elements**

A lens with a large aperture will likely have more lens elements than an equivalent type with a smaller maximum aperture since it becomes more difficult to reduce all lens aberrations over the entire image area as the lens

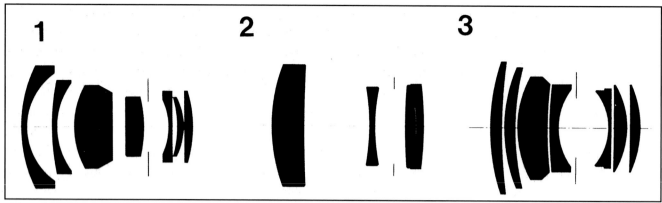

Above: Good image quality can be obtained from a normal or short telephoto lens with a "standard" aperture with four or five lens elements. (2) Wide-angle lenses (1) and large aperture lenses in any focal length (3) need more elements to correct the lens aberrations over the entire image area.

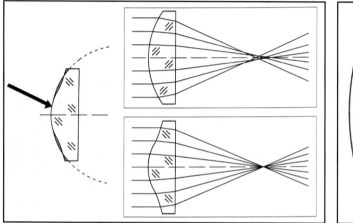 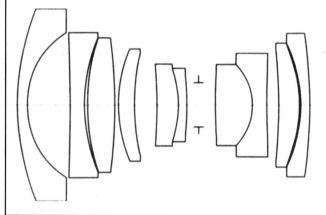

Above, Left: The use of lens elements with aspheric surfaces can reduce or eliminate some lens aberrations. *Above, Right:* Two aspherical lens surfaces are contained in the design of the 30mm lens for the XPan camera. *Below:* This helped in producing the corner to corner quality and illumination in the panoramic images taken with this camera.

aperture increases. You will likely find more elements in a wide-angle lens as the larger area coverage makes it more difficult to achieve corner to corner quality. However, this does not mean that a larger number of elements automatically assures a better quality lens. A good lens designer may come up with a better lens that has fewer elements by applying the latest design techniques and using the latest types of glass, or a lens with fewer elements may simply be better because the manufacturing and testing standards are on a higher level.

● Aspheric Lens Elements

As lens apertures are increased, zoom ranges are made longer, wide-angle lenses appear with wider angles and lens designing becomes more difficult. Lens designers have found a solution to some of the problems by using aspheric lens elements. While the use of aspheric elements can simplify lens design, and can produce a better quality lens of a specific type, this increased performance cannot be automatically guaranteed. Another lens designer may find a way to produce a lens of equal or better quality.

There are at least three ways to produce aspheric lens elements, but all manufacturing processes are difficult. As a result, lens manufacturers do not use aspheric lens elements unless absolutely essential.

Since the use of aspheric elements in camera lenses only started to be emphasized recently, one might come to the conclusion that this is something completely new. Aspheric lens elements, however, have been manufactured in Germany and used in lenses for optical instruments since 1937.

● Apochromatic Lenses

Like a prism, a lens element disperses white light into the different colors of the spectrum. The different colored rays form their images at different distances from the lens and, consequently, also produce images of different sizes. One of the tasks of the lens designer is to correct this so-called chromatic aberration, and to come up with a lens design where the different colored lights' rays produce images of the same size on the same plane.

The most important task is to correct every lens as well as possible for the blue and red colors of the spec-

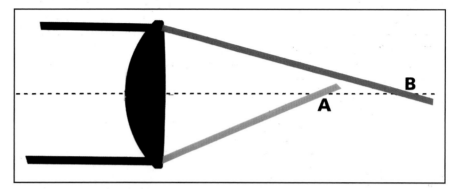

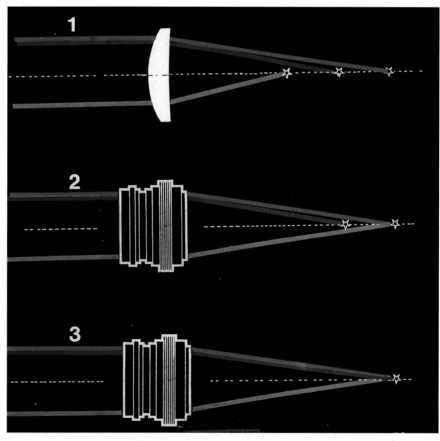

*Top: A single lens element disperses the colors of the white light with the blue light rays forming an image closer to the lens than the red rays This is shown in A in this top illustration, and in 1 on the bottom illustration. **Bottom:** Camera lenses are corrected mainly so the blue and red light forms the image in the same plane (2). In an apochromatic lens design the green light also forms the image in the same plane (3). A Carl Zeiss Superachromat is corrected for practically all colors of the spectrum.*

This photo illustrates the image quality that is possible with an apochromatic lens. Notice the sharp lines—without a touch of color fringing—illustrated in this image taken in Germany. Taken with a 350mm apochromatic lens on the 6cm x 6cm format (equivalent to 230mm on 35mm).

An example from the American space program taken with a 250mm Sonnar Superachromat from about 160 miles above the ground on 70mm Ektachrome film. This image shows the city of St. Louis with the juncture of the Mississippi and Missouri rivers. (Image courtesy of NASA.)

trum without being too concerned about the colors that comprise the secondary spectrum. Camera lenses in the standard, wide-angle, and shorter telephoto focal lengths that are well corrected for blue and red can produce superb image sharpness, even on today's high resolution films, when used in standard applications.

On the other hand, long focal length lenses corrected for red and blue only may produce a color fringe, or a slight unsharpness along sharp dividing lines between light and dark colors. This residual chromatic aberration may not be objectionable or even noticeable if "ordinary" photographic images are not enlarged beyond common standards. For best image quality with long focal length lenses, however, consider an apochromatic lens. Apochromatic lenses, also called "apo lenses" are clearly promoted as such by their manufacturers.

Apochromatic lenses are corrected not only for blue and red, but for green as well (and perhaps for some or all of the other colors between red and blue). The Zeiss Superachromats, developed in 1972, are, for all practical purposes, fully corrected for all of the colors in the spectrum. This extensive correction is accomplished in many apochromatic lenses by utilizing some lens elements made from materials other than glass. Fluorite, an artificially crystallized form of calcium fluoride, and a glass/fluorite blend are two of the materials used to manufacture these lens types.

These crystallized materials may be more temperature-sensitive than glass, making the focus setting somewhat dependent on the temperature. Always focus these lenses visually on the focusing screen, not based on the distance setting on the focusing ring. To accomplish focus at infinity, the focusing ring on such a lens may also turn beyond the infinity setting.

Apochromatic correction is also found in shorter focal length lenses used for special critical applications such as reproduction work, color separations and, in some wide-angle lenses used for critical large format photography.

Incidentally, apochromatic lens design is not a completely new idea. It was developed by Dr. Ernst Abbe at Zeiss in 1880.

● **Wide-Angle Design**
Optically True Wide-Angle Design. From a photographic point of view, all lenses with a focal length shorter than standard are considered wide-angles. From an optical design point of view, such lenses can be of two different

Left: In an optically true wide-angle lens, the rear element is close to the image plane as the principle plane (H′) is within the lens design. (1) Retrofocus lenses have a long distance between the image plane and the rear element because the principal plane is behind the rear lens element (2). *Right:* Optically true wide-angle lenses are known for their superb image sharpness and practically non-existent distortion and are therefore ideal for critical architectural work.

Retrofocus type wide-angle lenses are designed for maximum image quality at long distances. The large depth of field range allows good foreground sharpness to be maintained.

Taken with a Carl Zeiss 50mm Distagon FLE lens (about 33mm focal length on 35mm) from a distance of about 2' (60cm) showing the image quality that the FLE design can produce.

types. Wide-angle lenses on large format cameras and other non-SLR camera types can be, and usually are, of the optically true wide-angle design.

The principal plane (nodal point) from which the focal length is measured is within the physical dimension of the lens as it is with standard focal length lenses. Because of the short focal length of wide-angle lenses, the image is formed closely behind the lens with the rear element of the lens positioned close to the image plane. On a Zeiss Biogon design, used on the Hasselblad Superwide, a unique medium format camera of the non-reflex type, the rear lens element is only about 18mm from the image plane. This leaves no room for a mirror to move up and down between the rear element and the image plane as is necessary on an SLR camera. Optically true wide-angle lenses therefore cannot be used on SLR cameras.

Optically true wide-angle lenses are known for their superb image sharpness and minimum degree of distortion, the best that can be obtained from a wide-angle lens. This lens design also maintains excellent image sharpness over the entire focusing range—at least down to about a 1:10 magnification. Optically true wide-angle lenses are therefore excellent not only for architectural work, but also for critical close-up photography.

Retrofocus Wide-Angle Designs. The long back-focus necessary to accommodate the mirror motion in SLR cameras can be obtained in another wide-angle lens design known as retrofocus, sometimes referred to as an inverted telephoto design. On the retrofocus lens design, the principal plane from which the focal length is measured is not within the physical limits of the lens but behind the surface of the rear lens element. The distance between the image plane and the rear element can therefore be longer than the focal length of the lens. For example, on a 40mm Distagon made by Zeiss, the principal plane is about 29mm behind the rear lens vertex, which means the rear element can be about 70mm from the image plane. Wide-angle lenses on SLR cameras are of this retrofocus design.

While retrofocus designs likely have a somewhat higher degree of distortion, they can have excellent image sharpness—at least at long distances. The long back-focus, however, makes it difficult to correct a retrofocus lens to a high degree over the entire focusing range. A compromise is necessary. Retrofocus lenses are designed to provide the best image quality at long distances where they are normally used. It is recommended to close the aperture when photographing at closer distances below about 7' (2 meters) to maintain corner to corner sharpness.

Floating Lens Element Design. Lens designers have found a way to improve the image quality of retrofocus type lenses at closer distances with a lens design with floating lens elements (FLE), sometimes also described as close range correction. Some of the elements within such a

Floating lens element design produces better image quality at closer distances.

lens can be moved with a separate lens control, and this control should be set to the proper position when the lens is used at closer distances. Be sure to make this floating lens element adjustment, based on the subject distance, before you focus the lens with the normal focusing ring. If you focus the image first and set the FLE calibration ring afterward, the image will be out of focus. On some FLE wide-angle lenses, the floating lens elements may be moved automatically when the focusing ring is turned, eliminating the need for a separate adjustment. Floating lens element designs may not produce better image quality at long distances, but will definitely do so for close-ups.

Fisheye Lenses. Wide-angle lenses that produce straight verticals and

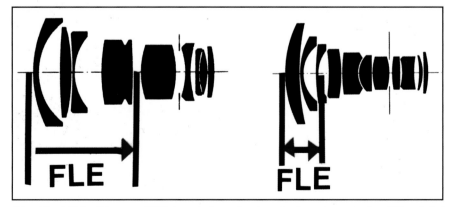

Two Carl Zeiss Distagon FLE lens designs showing the lens elements that "float" for close-up photography. (Carl Zeiss Distagons, 50mm left, 40mm right).

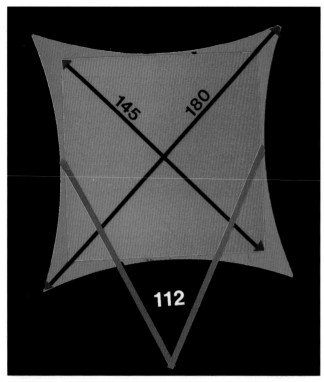

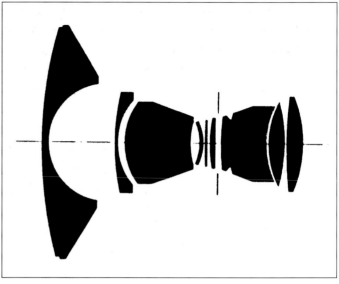

Left: The diagonal angle of view of a fisheye lens is completely out of proportion to the horizontal or vertical angle producing the curvature in the image. *Above:* A fisheye lens design. (*Carl Zeiss 30mm Distagon f/3.5 for the medium format*)

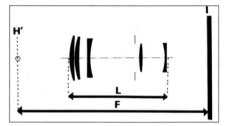

Left: Perspective control produced the straight and parallel vertical lines in this beautiful building. Carl Zeiss PC Mutar teleconverter with 50mm Distagon lens. *Above:* In an optically true telephoto design, the principle plane (H′) from which the focal length (F) is measured is in front of the lens, making the lens physically shorter (L) than its focal length.

horizontals over the image area are referred to as rectilinear wide-angle lenses. Some lenses, called fisheye lenses, are designed to produce rectilinear distortion. In a fisheye design, the diagonal angle of view, which is usually around 180°, is completely out of proportion to the horizontal or vertical angle of view and is not related to the focal length of the lens. For example, you can find fisheye lenses with a 180° diagonal angle of view with focal lengths of 15mm or 8mm. The fisheye lens design produces a curvature in all straight lines that do not pass through the center of the image, resulting in exaggerated barrel distortion and strangely beautiful images.

Some fisheye lenses produce a circular image that covers only the central area of the film—perhaps an image with a 23mm circle on the 24mm x 36mm 35mm frame. The effect can be striking, but it is largely the circular image that attracts attention. The subject, usually reproduced on a small scale, is often secondary. The effect wears off quickly, and all such pictures start to look alike. These lenses have limited application in serious photography.

Other fisheye lenses cover the entire image format from corner to corner like any other lens. They are known as full-frame fisheye lenses. The focal length is long enough to produce a relatively large image in the center and, at the same time, also embraces surrounding subjects from corner to corner within a 180° diagonal field. The distortion of the fisheye lens is completely unrelated to sharpness. Such lenses can produce good sharpness and even illumination from corner to corner, even with the lens aperture wide open. Full-frame fisheye lenses have excellent applications in any field of photography as they allow us to record subjects different from the way we see them with our eyes.

● **Telephoto Lenses**

From a photographic point of view, any lens with a focal length longer than standard is referred to as a telephoto or tele lens. From an optical point of view they must be separated into long focal length and optically true telephoto types.

In a long focal length design, the principal plane from which the focal length is measured is within the design of the lens. The longer the focal length, the longer the physical dimension of the lens. This lens design is usually used for shorter telephotos where the physical size of the lens is not as much of a hindrance.

Optically True Telephoto Types. An optically true telephoto lens is a specific optical design with a positive front and a negative rear section. The principal plane, from which the focal length is measured, is not within the physical dimensions of the lens, but somewhere in front of the lens. This allows for a more compact lens design—one shorter than the focal length that is obviously desirable for long telephoto lenses. For example, on a 250mm Zeiss Tele-Tessar, the rear principal plane is about 18mm in front of the front lens element, thus keeping the physical dimension of the lens down to about 160mm.

•Telephoto Lenses for Close-Up Work. As the focal length of a lens increases, the minimum focusing distance typically increases as well. The relatively long focusing distances of many tele lenses may give some photographers the impression that these lenses are meant for long distance photography only. This is not so. The focusing distances are limited for mechanical design reasons—especially on the larger and heavier lenses for medium format cameras. All tele lenses can be used at closer distances when used in conjunction with close-up accessories. Extension tubes are perfect for this purpose. Since such lenses are designed to produce the best image quality at long distances, I recommend checking the image quality at closer distances before using them for an important project.

Mirror Lenses. Some designers have found it advantageous to combine lens elements with a mirror when designing long telephoto lenses, using

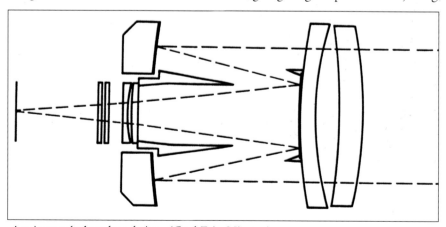

A mirror telephoto lens design. (Carl Zeiss Mirotar)

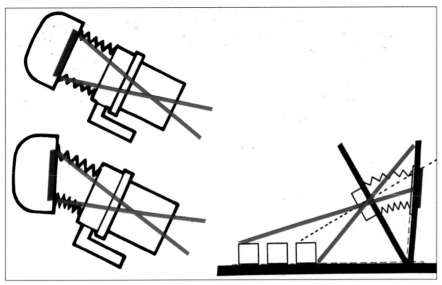

If the image plane is tilted around its center, the covering power of the lens need not be increased (left). When the lens is tilted around its optical axis, the lens must have a larger covering power for the same image size (right).

Left: *Shifting the lens or image plane may move the image recording area beyond the covering power of the lens, requiring lenses with a covering power larger than the image format.*

the principle of telescopes used for astronomical observations. Mirror lenses can be made physically shorter than telephoto types but the mirror probably requires a larger lens diameter. It is not possible to make a general statement regarding the image quality of mirror lenses compared to telephoto types made from lens elements only. It would require a comparison of two specific lenses. Check the specifications, size and weight, and quality diagrams, if available, or make your own quality tests. Mirror lenses have one aperture only, usually f/8 or f/11, or perhaps f/5.6. Depth of field control is therefore not possible.

Using Telephotos on a Tripod. To equalize weight distribution and provide better steadiness, long telephoto lenses are usually mounted on a tripod by means of the tripod socket on the lens, rather than the one on the camera. If you work with a camera that must be turned for verticals, such as a 35mm or 6cm x 4.5cm type, it can be helpful to have a tele lens with a revolving mounting system, meaning a rotatable tripod socket. You can then turn the camera/lens combination without tilting the tripod head.

● Shift Control, PC Lenses, and PC Teleconverters

Shift control allows either the lens or the image plane to move up, down, or sideways while remaining parallel to each other. This application is used mainly in product and architectural photography to maintain parallel vertical or horizontal lines. The shift motion can be accomplished by physically moving the lens or image plane as done in a large format camera and in special medium format camera types.

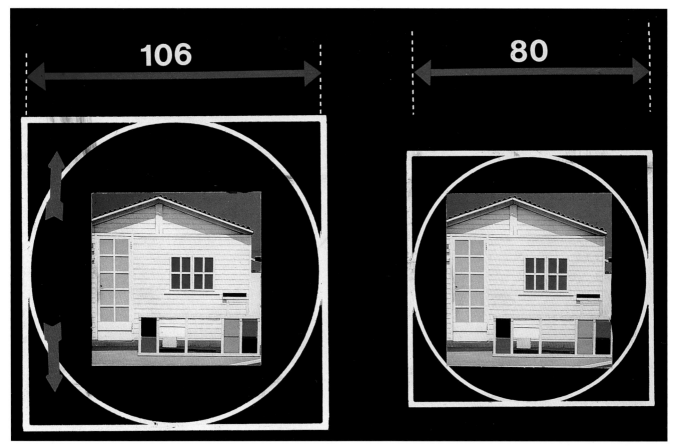

A PC lens or PC teleconverter, in combination with a regular lens, must have a larger covering power than the image format so the image can be shifted within the larger circle. The Carl Zeiss PC Mutar converter, for example, increases the 80mm image circle of the lens to 106mm.

It can also be accomplished with a lens or teleconverter that has a built-in shift control. Such lenses are known as perspective control (PC) lenses or PC teleconverters. The maximum possible amount of shift may be limited by physical reasons but, more often, is limited by the covering power of the lens.

● **Tilt Possibilities and Controls**
Tilting, as the name indicates, refers to the tilting of either the lens or the image plane so the two are no longer parallel. This tilt motion increases the range of sharpness along one subject plane far beyond what the depth of field of the lens could do. Tilting has wide applications—from tabletop still life and product photography to out-

door fine art work. The tilting may be accomplished in the camera body either by tilting the lens plane, the image plane, or both. If the tilting is done around the center of the image plane, the lens need not have a larger covering power. Good image quality and illumination is achieved with any lens that is designed for general photography on that image format. If the tilting is done in the lens plane, the

This tilt motion increases the range of sharpness along one subject plane. . .

lens needs a larger covering power. Tilting can also be accomplished with special lenses with tilt control. In either case the tilt motion may be combined with shift motion capability.

More details about the use and application of shift and tilt control are found in chapter 5 of this book.

● **Lenses with an Image Stabilizer**
Camera shake, either in handheld photography or when working from a tripod, is a major cause of lack of image sharpness, especially with longer telephoto lenses. The longer the focal

length of the lens, the greater the danger of camera motion and the shorter the shutter speed needs to be to maintain image sharpness. Lenses with a built-in image stabilizer, designed to

Teleconverters are convenient to carry and offer the opportunity to quickly switch to a longer focal length for a closer view. Taken with a 2x converter and a 180mm lens resulting in a 360mm telephoto on a medium format camera (about 250mm on a 35mm).

counteract the effect of camera shake, have appeared on the market. These lenses contain gyro sensors that convert shaky movements into electronic signals. The signals then move a lens component in relation to the optical axis to counteract image movement. According to reports from photographers who have used such lenses, the system works. Image stabilizing systems of this type have been available for binoculars for some time.

● **Teleconverters**
Characteristics of Teleconverters. Teleconverters, also called tele extenders, are optical components that contain several lens elements. They are used in combination with a regular camera lens with the teleconverter mounted between camera and lens,

like an extension tube. The teleconverter increases the focal length of the lens. A 2x converter doubles the focal length of the lens. When combined with a 250mm lens, a 500mm focal length is achieved. A 1.4x converter

Being able to use a converter with various lenses is another nice advantage.

increases the focal length 1.4 times, so the focal length of a 100mm lens is increased to 140mm. A 1.7x converter changes a 100mm lens into one with a 170mm focal length.

Some teleconverters can be used with all lenses in a camera system, others are made for specific lenses only, either for optical or mechanical reasons. Check the manufacturer's specification sheets. If you work with a

zoom lens, be sure to determine whether the teleconverter can be used with zoom lenses and, if so, what image quality can be expected.

Teleconverters offer compact size and low weight. Using them, you can obtain a longer focal length with a physically shorter lens. This is especially appreciated by those carrying equipment on airplanes. Being able to use a converter with various lenses is another nice advantage. In using three lenses and one converter, you end up with six different focal lengths.

Focusing Range and Area Coverage with Teleconverters. The focusing range of the prime lens is maintained when combined with a teleconverter. If a 180mm lens focuses down to 5' (1.55m), for example, it still focuses down to 5' when combined with a converter. That means we have a 250mm (with 1.4x) or a 360mm (with 2x) lens that focuses as close as 5'—probably closer than a telephoto lens of the same focal length.

A converter might even serve as a close-up accessory instead of, or in addition to, an extension tube. For example, if a lens covers an 8-inch area at the minimum focusing distance of the lens, it covers an area as small as 4 inches from the same distance when it is combined with a 2x extender.

Exposure with Teleconverters. While teleconverters offer many advantages, they have one drawback—they steal light. With any 2x converter, the light that reaches the film is reduced by two f-stops. A 2x converter combined with a 50mm f/2 lens

If the basic lens (180mm in this example) focuses down to 5' (1.55m) (top), it will focus to the same distance when used in combination with a teleconverter, resulting, in this case, in a 360mm lens with a 5' minimum focusing distance (bottom).

results in a 100mm focal length with a maximum aperture of f/4. A 1.4x converter causes a loss of one f-stop, and a 1.7x converter steals 1½ f-stops.

You must compensate for this loss of light when taking a meter reading with a separate exposure meter. If the light is measured through the lens with a built-in meter or meterprism viewfinder, you need not worry. Whatever the built-in meter shows is correct since the light is also measured through the teleconverter.

Before purchasing a teleconverter, determine whether this light loss may become objectionable in your field of photography. If so, determine whether investing in a longer and faster tele lens may be a better choice.

● **Soft Focus Lenses**

Soft focus lenses, available for cameras in most image formats, produce an image that is haloed to give the image a luminous appearance. This effect is often desirable in portrait and fashion photography, and also in advertising images of beauty products, where the softened effect adds a more glamorous feeling to the image.

The soft focus effect can be created in the lens by under-correcting the lens for spherical aberration, which may be combined with a disc with small circular openings within the lens. The disc or discs control the amount of diffusion. With such a lens, the degree of softness depends on the lens aperture, providing a large degree of softness at large apertures, and almost-sharp images with very little softness when the lens aperture is closed down. The diaphragm must always be set at the aperture that produces the desired degree of softness. I feel this is a seri-

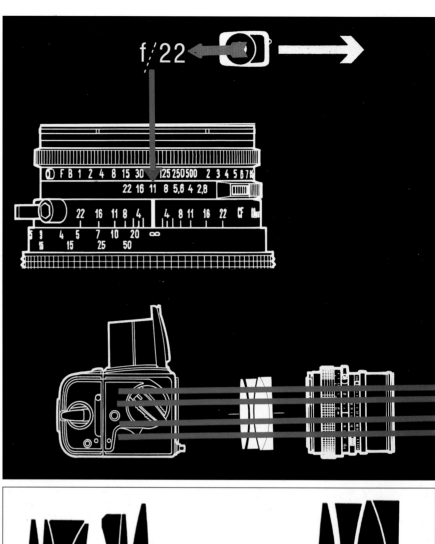

Top: When measuring the light with a handheld meter, exposure must be increased—from f/22 to f/11 with a 2x converter, in this example (top). This correction must not be made with TTL metering, since the light is measured through the converter (bottom). Bottom: Two teleconverter designs. A 2x extender (left) and a 1.4x extender (right), showing that a quality extender may need as many elements as, if not more elements than, a basic lens. Facing Page: Soft focus filters produce a more romantic feeling, which can be especially desirable in backlit outdoor scenes. This image was produced with a Carl Zeiss Softar #1.

Left: Soft focus images must maintain some degree of sharpness to look natural. Although a Carl Zeiss Softar filter was used in this case, the image gives a feeling of sharpness and the product names are quite legible. Right: Soft focus filters can be attached to the front of various lenses and can therefore convert standard, wide-angle, and telephoto lenses into soft focus types.

ous disadvantage in many applications where the diaphragm must be set at the aperture that produces the desired depth of field. Using a soft focus lens also means that all soft focus images must be produced at that particular focal length of the lens.

A similar and equally pleasing softness can be added to an image by attaching a soft filter to the front of an ordinary sharp lens. Soft focus filters can be attached to any focal length lens (as long as the filter is as large as the front diameter of the lens), allowing you to create soft focus images with standard, wide-angle, and telephotos at a fraction of the cost of a soft focus lens.

Soft focus filters create softness in various ways. One is by scattering the light before it enters the lens with a pattern of transparent and non-transparent areas on the filter. In another method, the image softness is achieved with a number of spherical mini lenses

of different diameters on one of the filter surfaces. This is the principle applied in the Zeiss Softar filters.

With such filters, the degree of softness is the same at all lens apertures. This allows you to set the lens aperture for the desired depth of field.

Soft focus photographs must have some sharpness in the image in order to look natural. Our eyes are not accustomed to seeing things that are completely blurred. We expect to see something in sharp focus whether we are looking at the actual subject or a photographic image. A good soft focus lens or filter must produce sharp images with diffused outlines created by the highlights bleeding into the shaded areas, not by blurring the image and giving the impression of unsharpness. Whichever soft focus

device you plan to use, assure yourself that it maintains image sharpness and does not produce an overall blur. A good soft focus filter also should not reduce the contrast in the image.

Due to the fact that the soft focus effect (whether it is obtained with lenses or filters) is produced by bleeding the highlights into the shaded areas, you may want to watch the effect carefully on the focusing screen.

A good soft focus filter also should not reduce the contrast in the image.

The halo that is produced around the highlights can be distracting if it is too obvious or if it is around a large part of the subject. This is commonly seen in front of darker backgrounds. If you find it distracting, use less diffusion, change the lighting, turn the model so bright areas are in the shade, or place the person or subject against a lighter background.

● Infrared, Ultraviolet and Fluorescence Photography

The light that is visible to the human eye has wavelengths from about 400nm (violet) to about 700nm (red). Beyond the red wavelength lies infrared radiation, which is not visible to the eye but can be recorded photographically on special infrared emulsions. At the other end of the spectrum, beyond the violet, is ultraviolet radiation, which is also used in photography. The ultraviolet wavelengths are divided into three bands: long wave (320nm–400nm), middle wave (280nm–320nm), and short wave ultraviolet (200nm–280nm).

Lenses for Infrared Photography. Infrared radiation has important applications in scientific photography and exciting possibilities for the photographer seeking to produce images with unusual colors or tonal renditions on black and white film. For most photographic purposes, light wavelengths from 700nm to about 900nm are used in combination with a red filter and special color or black and white infrared films that are available in some camera formats. Other color filters can also be used for experimenting in color photography.

Focusing in Infrared Photography. All photographic lenses transmit infrared radiation and are therefore usable. The lenses, however, are corrected for the visible range of light. Infrared light, with its longer wavelengths, forms the image behind the film plane. With color film, this shift of focus presents no problems because the image is not formed by infrared alone but by a combination of infrared and visible light. Images on infrared-sensitive black and white film, on the other hand, will be out of focus at the film plane. For long-distance shots at f/11 or smaller, depth of field may take care of the discrepancy. In close-up photography and when using larger apertures, a focus adjustment of about $1/200$ of the lens's focal length must be made.

Many lenses have an infrared focusing index. If your lens has one, proceed as follows for focusing an SLR camera: Focus the image as usual on the focusing screen. Read the distance on the focusing ring opposite the regular index. Finally, turn the focusing ring to set this distance opposite the infrared focusing index.

The 250mm Sonnar Superachromat for the 6cm x 6cm format, originally designed for NASA applications,

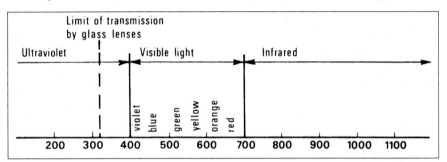

*Top: Radiation diagram showing the range of visible light and the infrared and ultraviolet ranges at the two ends. **Bottom:** Image taken on infrared film with Carl Zeiss 250mm Sonnar Superachromat, which is corrected into the infrared range and does not require a focus adjustment. NASA Space Program.*

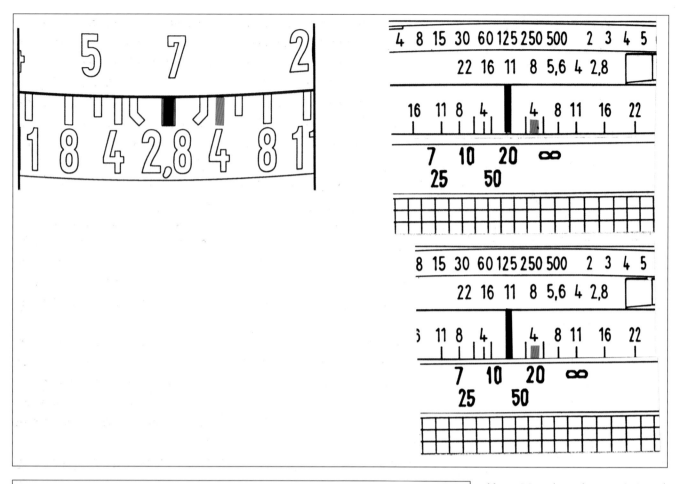

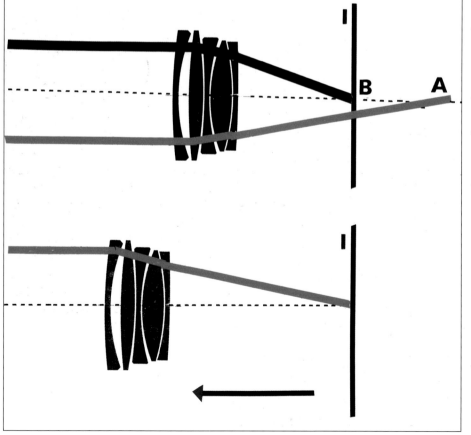

Above: *Many lenses have an infrared focusing index (red mark) in addition to the regular index (to the left of the infrared mark). For black and white infrared work, the lens is focused visually as is normally done. Read the focused distance on the focusing ring (20m in the example on the right), then set the focused distance (20m) opposite the infrared focusing index (bottom right).* **Left** *(top) Infrared light forms its image further from the lens (A) than the visible light (B). The lens must be moved forward to bring the infrared image onto the image plane (I) (bottom).*

is chromatically corrected for infrared radiation up to 1000nm. The infrared image is formed at the same plane as that for the visible light and a focus adjustment is not necessary. This is one of the few, if not the only modern, high quality lens that has a single layer, not a multicoating. Multicoating would reflect some of the infrared light rays that are necessary for infrared photography.

Ultraviolet Photography. There are two distinctly different methods of using ultraviolet radiation in photography. In ultraviolet photography, the subject is illuminated with ultraviolet (UV) light and photographed through a filter that absorbs all the visible light. UV photography is used mainly in the scientific field for the examination of altered documents, engravings, tapestries, paintings, sculptures, etc.

Normal photographic emulsions are sensitive far into the UV region (to approximately 250nm) and the standard black and white films can therefore be used for most UV photography. Color films can also be used for UV photography, but they offer no advantage over black and white, as only the blue-sensitive layer reacts to the UV radiation. Black and white materials actually give better results.

The optical glass used in camera lenses transmits some ultraviolet light above wavelengths of approximately 400nm. To what extent such light is transmitted depends on the type of glass; only a few regular camera lenses are usable for UV work in the longer wavelengths. For photographing in the shorter wavelengths, a lens with quartz elements is necessary.

Fluorescence Photography. Fluorescence photography concerns photographing objects and materials that fluoresce when subjected to UV light.

To what extent such light is transmitted depends on the type of glass. . .

The radiation reflected from the subject has a longer wavelength than the UV light and, therefore, is visible to the human eye as the typical fluorescent colors.

Fluorescence photography offers great opportunities to produce color images with unusual and striking colors. If the product does not fluoresce naturally, you can apply fluorescent paint.

Left: In fluorescence photography, we photograph the visible light that is reflected off the subject illuminated by ultraviolet light rays. Above: The subject is illuminated with a light source with ultraviolet light rays such as a BLB fluorescent tube or electronic flash with an 18A filter that absorbs the visible light. A UV filter over the lens reduces a bluish cast in the picture.

The light that reaches the camera in fluorescence photography is from the visible part of the spectrum. Therefore, regular camera lenses can be used, if necessary, in combination with close-up lenses and filters. Focusing is done in the normal fashion. A UV filter should be placed over the lens to eliminate a bluish cast.

● **Lens Names and Engravings**
Most camera lenses today carry only the name of the camera and/or lens manufacturer, in addition to the focal length and maximum aperture. All lenses made for a specific camera and/or made by the same company carry the same names. Lens engravings provide no information on the lens type or lens design.

Quality lenses made in Europe, however, still carry today, as they have done for more than a hundred years, not only the name of the manufacturer, but also a name that specifies the lens type and lens design. Before the computer age, designing a new lens was a time-consuming process, and when completed, many lenses were considered great accomplishments

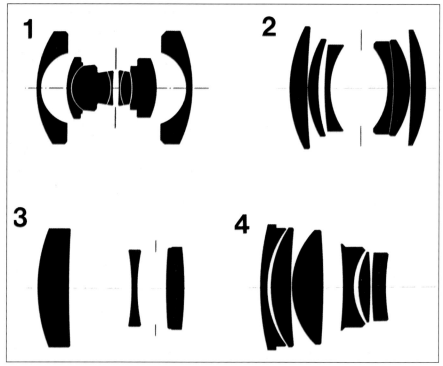

Four different lens designs: (1) Rodenstock Apo-Grandagon wide-angle lens with large covering power, courtesy of Rodenstock; (2) a symmetrical Carl Zeiss Planar design (3); a typical Carl Zeiss Tessar design in a short telephoto focal length, and (4) apochromatic telephoto design.

that justified a special recognition, a special name. Many lens designs have made their designers famous. Two of the best known camera lenses, the Tessar and Planar, are the work of Dr. Paul Rudolph. The Biogon is the work of Dr. Ludwig Bertele.

European-made lenses have names that indicate a specific lens design. This does not mean that one design is better than another, but simply that a specific design was selected as the most suitable choice for that particular focal length and use of lens. Lenses with the same name may be available in different focal lengths, may be made for different camera formats or for different camera makes, or may be made for film cameras as well as cameras for digital recording. As long as the lenses have the same name, they are basically the same lens design.

A few examples from the Carl Zeiss line: The Tessar is a classic four-element lens design that is often referred to as the eagle eye of the camera. The Tessar design, which goes back to 1902, was made possible by the use of high refractive glass types. Tele-Tessars are optically true telephotos consisting of a positive front section and a negative rear section, separated by a large air space, which helps in producing a flat field. Planar lenses are of a symmetrical design, with the name "plano" meaning "a flat field." Biogon is an optically true wide-angle design, and Distagon is a retrofocus wide-angle design. Grandagons from Rodenstock are wide-angle lenses with a large covering power that allows for shift and tilt motions.

Some of these lenses were designed a long time ago: the Planar design goes back to 1896, Tele-Tessar to 1919, and Biogon to 1953. This naturally does not mean that today's Planar or Sonnar lenses are identical to those designed years ago. Today's lenses have the same basic design but have newer glass types, different curvatures, and perhaps more lens elements to match the quality of today's

As long as the lenses have the same name, they are basically the same lens design.

lens to the quality of today's high resolution films.

● Lenses for Enlarging

Though it was once recommended that photographers use their camera lenses on enlargers, most photographers seemed to be reluctant to take an expensive camera lens into the darkroom. Just as well. While the lens on an enlarger needs to have good quality to reproduce the sharpness from the negative on the enlarging paper, the enlarging lens does not need the controls that are necessary for use on the camera. Some of the lens controls may even get in the way of the enlarging operation. You are probably better off working with a good quality lens made specifically for enlarging.

Keep in mind that the quality of a print can only be as good as the weakest link in the equipment chain. It makes no sense to produce the images in the camera with a top quality lens and then sacrifice the results with an enlarging lens that is not capable of reproducing the quality on the print. It is wise to select a lens that provides corner to corner sharpness with the aperture wide open and produces prints without any visible darkening in the corners. Even a slight darkening can attract attention and become distracting on a print.

● Protecting Your Lenses

Lenses can be the most expensive components of a camera system. It makes sense to keep them clean and in perfect operating condition. Protect them as much as possible, keeping Lenses are not only the component most likely to become damaged, they are probably the most expensive to repair. Attaching a UV or haze filter to the front of the lens provides further protection against lens damage. These filters do not change the colors or gray tones to any noticeable degree, are easier to clean than the lens itself, and are less expensive to replace than the front element of a lens. Each lens should be equipped with its own filter.

Protect them as much as possible, keeping them in cases when not in use.

them in cases when not in use. Placing front and rear covers on the lenses offers further protection from damage and dirt. Covering the rear of the lens is especially important, as it is difficult to clean.

Most modern lenses utilize mechanical couplings in the rear that must also be carefully protected from damage. They may have electronic connections that must be kept absolutely clean as they will not properly transmit the signals from the lens to the camera (and vice versa) if dirty or damaged.

It is too time-consuming to switch filters from one lens to another every time a new lens is selected. For color photography, it is best to use identical filters made by the same company on every lens to avoid potential differences in color rendition.

Lens shades are another protective option. They prevent snow or raindrops from falling on the lens element and creating diffusion effects.

CHAPTER

3

LENS QUALITY

● ●

● What Determines the Quality of a Lens?

Lens design determines the image quality that a lens is capable of producing in any camera. Image quality, however, is equally, if not more dependent upon the accuracy with which each lens element is ground and polished, the accuracy and the workmanship that goes into each mechanical component of the lens mount, and the precision that is used when assembling the components. Perfect centering of every optical component within the lens mount is a primary, yet often overlooked, factor. The larger the lens diameter, the more critical perfect centering becomes.

The performance of a lens and its controls is greatly determined both by lens construction and the materials used for mounting and moving the lens elements within the barrel. This performance should be unaffected by constant usage. The most beautifully designed lens cannot produce exceptional quality unless it is perfectly constructed. The difference between ordinary, good, and superb

camera lenses depends upon the manufacturing and assembly precision and the care taken in testing the final product before it leaves the factory.

There are no shortcuts to quality. Producing perfect lenses is a time-consuming process, and for this reason, quality lenses cannot be inexpensive.

● Lens Aberrations

A single lens element produces an image that is affected by many aberrations, such as spherical and chromatic aberration, coma, astigmatism, field curvature, and distortion. These aberrations can be reduced by combining

A single lens element produces an image that is affected by many aberrations. . .

various lens elements of different curvatures and thicknesses, made from different types of glass and arranged in different ways within the lens mount. It is the lens designer's job to find a combination that reduces aberrations to a point where they are not visible or objectionable in the applications for which the lens is made.

Chromatic Aberration. A single lens element separates white light into the different colors of the spectrum (see discussion on apochromatic lenses, pages 33–34). By adding additional lens elements, the lens designer must try to bring the different colored rays together so they form a satisfactory image in the applications for which the lens is designed.

Spherical Aberration. Light rays that enter through the outer edges of a single lens element form an image at a different distance than the rays entering closer to the center of the lens. These rays must be brought together to form an image in a single plane. Chromatic and spherical aberration affect the image quality across the entire image area. The remaining spherical aberration can be reduced by closing down the aperture.

Coma. Coma occurs when light rays enter the lens at an angle and, therefore, appears mainly (or only) on

Image quality and lens construction are exceptionally important in critical applications such as images produced for the NASA space program. Taken with Carl Zeiss Planar 100mm over the western part of the U.S.

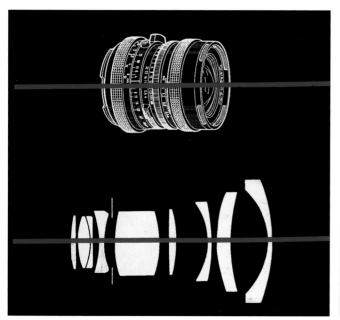

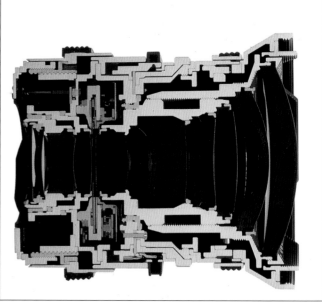

Left: A lens can produce the calculated image quality only if all the lens elements are perfectly centered in relation to the optical axis. *Right:* Lens barrels are composed of several intricate parts. As all the lens elements must remain precisely positioned when the entire lens or part of the lens (i.e., focusing) is moved, utmost attention to detail is a requirement in the design and manufacture of the lens barrel. In quality lenses, the important components are usually made of metal.

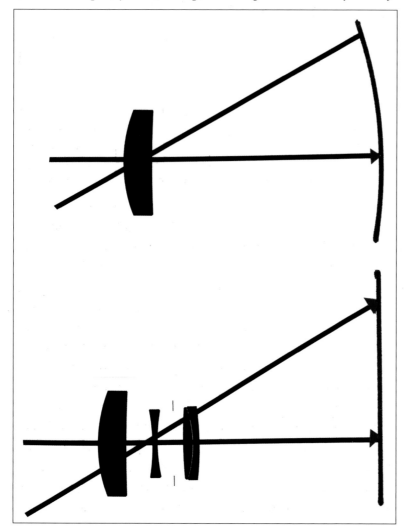

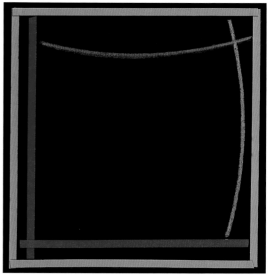

Left: A single lens element forms its image on a curved plane (top). This curvature of field, like all the other aberrations, can be reduced through use of a combination of different lens elements. *Above:* In lens design, distortion refers to the inability of a lens to record straight lines as straight lines over the entire image area. When viewing an image taken with a lens with distortion, straight lines appear to curve inward or outward.

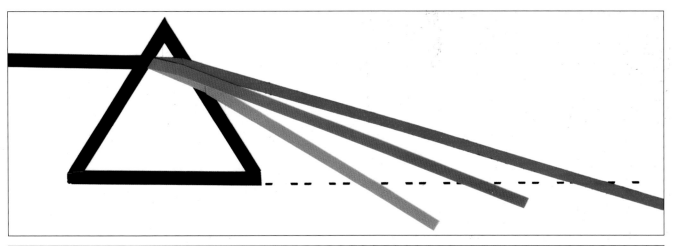

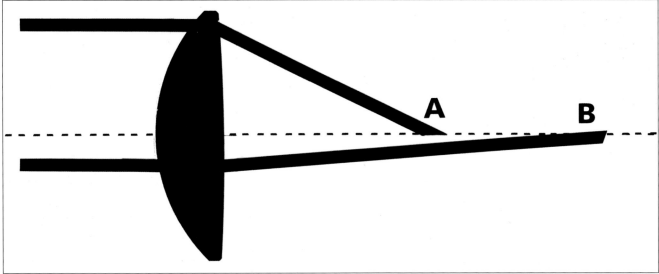

Top: A prism disperses white light into the different colors of the spectrum. A single positive lens element does the same, forming the blue image closer to the lens than those formed by green and red light. **Bottom:** Spherical aberration is created by light rays going through a positive lens element close to the edges, forming the image (A) closer to the lens than those entering the lens near the center (B).

the outside areas of the image. The point source appears as an image of a point with an asymmetrical tail attached at one end and resembles a moving comet.

Astigmatism. A lens has astigmatism if it forms the image of vertical and horizontal lines in the subject at different image planes, thus requiring different focus settings on the lens. This is naturally unacceptable in a high quality lens.

Field Curvature. A single lens element produces its image on a curved plane. The lens designer must try to "straighten" the image plane, reducing its curvature to a point where the sharpness is acceptable over the entire image area.

Some lenses are referred to as "flat field" types, meaning that they are exceptionally well corrected for field curvature, which is a main requirement for copying and color separation work. Process lenses are of this type. Other lenses that are not specifically called flat field may also produce images of exceptional flatness. The Planar types, for example, fall into this category. In some cases,

the term "flat field" may be used in advertising claims as there are no standards to separate "regular" from "flat field" types.

Distortion. Lens distortion is not associated with image sharpness but indicates to what extent a lens is capable of reproducing straight lines as perfectly straight over the entire image area. If the straight lines of a subject (a building, for example) are curved outward at the top and bottom, pincushion distortion occurs; when the lines curve inward the effect is called barrel distortion.

● Quality Specifications for Lenses

The quality of camera lenses used to be expressed solely by resolution—the number of lines per millimeter a lens is capable of reproducing as separate lines. Lens and photographic technicians have, however, found that the degree of sharpness we perceive is not only determined by the resolution of fine detail (the amount of detail we see), but even more by the edge sharpness of the lines within the image. This is known as acutance. Acutance values correlate directly with the viewer's perception of the sharpness of an image. A lens with a high acutance that is also capable of recording fine detail must be the choice for the ultimate sharpness.

The image-forming qualities of a lens are best expressed with modulation transfer function (MTF) diagrams. They are used throughout the camera lens industry. Some manufacturers publish these diagrams, some do not. They can be helpful to determine the performance of a lens or to compare the performance of different lenses made by the same company.

Most companies show MTF diagrams for a lens with the aperture wide open and somewhat closed down so you can see whether image sharpness improves by closing down the

Resolution is indicated by the number of lines per millimeter that can be recognized as separate lines in the image. How sharp an image appears, however, is determined more by the edge sharpness of the lines than the number of lines.

aperture. You can also see the quality of a lens at different subject distances—if the manufacturer has published this data. This is usually the case for large format camera lenses. MTF diagrams for large format lenses can

also show how much shifting is possible before the image moves out of the usable image circle.

MTF diagrams cannot necessarily be used to compare the quality of lenses made by different companies. There are no standards within the industry.

Most companies publish these diagrams based solely on the computer printout—what the lens design should produce based on its design—and do not take into account the manufacturing precision.

Some companies publish the MTF curves for the actual finished lens—the lens you buy and use. (To the best of my knowledge, Carl Zeiss is the only company publishing such curves.) Such curves are based not only on the design but also take into account the manufacturing precision, which, to a great extent, determines the final performance of a lens.

Understanding MTF Diagrams. There are some variations among the MTF diagrams that are published by different companies, but the basic elements are the same. The closer the curve is toward 1.0 or 100, the better the lens is. Most MTF diagrams have

Some manufacturers publish these diagrams, some do not.

MTF curves are usually shown with the lens aperture wide open (left) and closed down about two stops (right) so you can see whether the quality improves at smaller apertures. This is the case with this lens—especially at the corners.

Top and bottom curves are for two different lenses made by the same company. The higher positioning of the lines indicates a better image quality for the top lens, especially at the edges and with the lens aperture wide open (Planar 80mm top, Planar 100mm bottom).

Diagrams indicate that this lens delivers better quality at close distances (left) than at infinity (right), both at maximum aperture (Makro-Planar 135mm).

three curves for the spatial frequencies of ten, twenty and forty lines per millimeter or five, ten and twenty lines per millimeter. The importance of the three line pairs depends somewhat on the application of the lens and the resolution of the film or the digital CCD or CMOS in the camera. As many films show a contrast loss at higher frequencies, the two upper curves are most important for general photography.

The horizontal axis has millimeter values starting with 0 on the left, indicating the center of the image. The values 10, 20, 30, etc., indicate the distance from the center. On the 35mm format, the quality at the edges is indicated at 18 (half of 36mm). On a horizontal 6cm x 4.5cm image format (54mm horizontally, 40mm vertically 68mm diagonally), the image quality at the top and bottom of the image is found at 20 (half of 40mm). The quality on the two sides is at 27 (half of 54mm), and the quality in the corners at 34 (half of 68mm).

MTF diagrams also have sets of curves with solid and dotted lines indicating sagittal and tangential orientation. Where the two lines are close together, the lens is well corrected in either orientation. A wider separation indicates some astigmatism or leftover amounts of other abberations at that point.

The left 0 position of the curves on MTF diagrams indicates the image quality in the center of the image. The figures on the bottom indicate the distances in millimeters from the center. The sides of a 2¼" square (54mm x 54mm) are thus at 27mm, the corners at 38mm (half of 76mm).

● **Quality at Different Apertures**
Good quality camera lenses made by recognized quality manufacturers should, and usually do, produce completely acceptable image sharpness over the entire image area with the lens aperture fully open. While there are some camera lenses that produce not only acceptable, but practically perfect sharpness in the corners at maximum aperture, most—even very good camera lenses—will show some decrease in sharpness toward the corners at maximum aperture under critical image evaluation (as under a 10x magnifying glass). Image sharpness, especially in the corners, almost always improves as the aperture is stopped

down. With the aperture closed down two f-stops, a decent camera lens should produce excellent or perfect corner to corner sharpness. (The above does not apply to lenses made specifically for large format cameras.)

Lens Quality at Small Apertures. When lens apertures become very small, a sharpness loss occurs again. This reduction in image quality has nothing to do with the lens or the lens design. The phenomenon has to do with the nature of light. Light going through a small opening spreads slightly at the edges—an effect known as diffraction. When the opening is below a certain diameter, the diffraction may affect the image sharpness over the entire image area.

To eliminate or reduce this loss of sharpness, manufacturers of high quality lenses limit the minimum aperture to a point where the quality loss is at least not objectionable. This explains why some of the best lenses may only stop down to f/16 or f/22. This limitation in the minimum aperture reduces the loss of sharpness on small and medium format cameras so that photographers need not be overly concerned about image quality when a small aperture is necessary for obtaining the desired depth of field. For critical work, large format camera lenses should not be closed beyond f/22 as the resulting sharpness loss caused by diffraction may produce a visible loss of image contrast on the large format.

● Quality with Large Format Camera Lenses
Because the lenses on large format cameras with swings and tilts (also called technical cameras) are rarely used at large apertures in commercial or architectural photography, these lenses are designed to produce good image quality only at small apertures—f/16 or f/22, the most frequently used apertures in this type of photography. At larger apertures, the images show a reduced contrast and unsatisfactory sharpness in the corners.

Large format camera lenses have larger apertures, such as f/4.5, only for the purpose of providing a bright image on the focusing screen. The larger apertures should therefore be considered only for focusing and evaluating the image on the focusing screen, not for creating the image in the camera. The images must be made with the aperture stopped down. The sharpness difference between large and small apertures is clearly documented on the MTF diagrams of such lenses. The above also applies if such view

Top: The MTF diagram for a large format camera lens clearly shows the large difference in the image sharpness, especially in the corners with the aperture wide open (left) and closed down to f/11 (right). **Bottom:** *Image quality of a large format camera lens used at f/11 with shift control. (Rodenstock 45mm on a medium format camera.)*

Some of the light going through any small opening is being refracted. This also happens in camera lenses at small apertures.

camera lenses are used on a camera designed for a smaller format.

Covering Power and Usable Image Circle of Large Format Lenses. The performance of large format camera lenses is usually shown on diagrams showing their covering power. In principle, the entire usable image circle indicated on such a chart can be used, at least

Lenses for digital cameras have some of their own requirements. . .

when the corners do not include important subject areas that need to have the ultimate sharpness. That may be the case when the corner areas include a sky or other background area. For best performance where corner to corner sharpness is expected, lens manufacturers usually recommend using only ⅔ to ¾ of the indicated image circle.

● Lens Quality and Performance for Digital Photography

Since there is a general preconception that sharpness in digital images does not meet the standard of high resolution films, one might get the impression that lens quality is not too important in digital work. That assumption is correct for point and shoot digital cameras, as it is for point and shoot film cameras where images are seldom enlarged to more than 4" x 6".

The quality of digital images has improved drastically within a short time and, since it is likely to improve further, we must have a more serious look at the camera and lens equipment if the images are used for professional

applications. Today, digital images, especially when produced in medium and large format cameras, can already match or may even surpass film quality. At present, a camera lens that produces a good image quality on film can also be expected to produce satisfactory sharpness when used for digital work, at least in travel, news, fashion and documentary applications, and for catalog work. This applies especially to lenses designed for medium format cameras where the CCD or CMOS in most digital backs uses only the center portion of the usable image circle.

Lenses for high quality digital photography have some of their own requirements, especially if the photography is done on a large format camera or with a digital back on a medium format type. Due to the pixel dimension, lens resolution should be targeted to the higher line pair frequencies. The lines for twenty or forty lines per millimeter spatial frequencies on MTF charts must therefore be considered more seriously. A proper resolution related to the pixel dimension is important in one-shot color digital photography to avoid the Moire effect.

In many cameras today, the CCD or CMOS sensor has a higher light requirement than film. It is therefore desirable to obtain the highest quality images at apertures larger than used in large format photography with film. Large format lens manufacturers have therefore introduced special lenses for digital photography that produce the highest resolving power and contrast at f/8 or f/11 (not f/22, which is normally used for film). The required larger aperture has a minor negative effect on the depth of field range since

the digital image is usually recorded on a smaller format. While sharpness filters in imaging software can upgrade an image and sharpen the edges, they cannot create details that don't exist on the original.

Lens designers also pay great attention to achieving excellent image field flatness since the CCD or CMOS is perfectly flat, more so than the film surface in any camera.

Computers allow for practically unlimited corrections and changes in the digital image. Digital enhancements should not be considered a replacement for image control in the camera, however. Although you can digitally straighten the slanted verticals of a building, for example, they can be straightened in technical cameras or in other cameras with PC lenses or PC teleconverters in a fraction of the time it takes to correct the image in the computer.

● Quality of Zoom Lenses

When zoom lenses appeared on the market years ago, image quality was not very good. Lens design techniques have changed. There are zoom lenses on the market today that produce images as good as, or close to the quality of, a fixed focal length lens (at

Above: As shown in these MTF diagrams, the image quality on zoom lenses varies with the focal length for the same lens and at maximum aperture. *Left:* A zoom lens can produce excellent image sharpness over the entire image area even with the lens aperture wide open (Hasselblad Zoom at 60mm).

A zoom lens is especially practical when working from a tripod because the desired portion of a scene can be captured without moving the camera.

least at some focal length settings). On any zoom lens, image sharpness varies with the focal length setting. No zoom lens can produce the sharpness of an equivalent fixed lens at every focal length over the entire zoom range. You may want to perform a critical test with your zoom lens so you know which focal length or lengths are best, and then use these settings for images where maximum sharpness is important and/or when the pictures must be made at the maximum lens aperture.

While no general statement can be made, a lens with a shorter zoom range may be preferable from a quality point of view, as it is difficult to design a lens that maintains good quality over a longer zoom range. Zoom lenses with a fixed aperture

You may want to perform a critical test with your zoom lens. . .

value are generally considered to be of better quality than those with a variable aperture value. Check published quality figures or perform your own quality tests.

● Quality with Teleconverters
In the past, teleconverters were often considered a "poor man's solution to telephotos," with converters being available at low prices but producing questionable sharpness. Things have changed. Many teleconverters available today produce a sharpness that comes close, or even matches, that of an equivalent longer focal length lens. A quality teleconverter may need as many or more lens elements than a prime lens and may consequently cost as much, or almost as much, even though the mechanical construction can be simpler since the converter does not need a focusing mechanism, aperture or shutter. Teleconverters usually have lens elements with shallow curves, which are more likely to produce stray light and lower the contrast of the image produced by the basic lens to some degree.

The image quality produced by a converter/lens combination varies from one lens to another. Lens designers usually design a converter to produce the very best quality for a specific lens or specific range of lenses—perhaps short or long telephotos. This information is not usually published in the specification sheets but may be available from the camera or lens manufacturer.

It is important to remember that a teleconverter can only produce good quality when combined with a high quality lens. The best teleconverter will produce an unacceptable image when combined with a lens of questionable sharpness because the converter makes the shortcomings of the basic lens more obvious. A 2x converter doubles all the faults of the basic lens. It is generally best to select a teleconverter made by the manufacturer of the lenses used on the camera.

We must also keep in mind that the use of a teleconverter means combining two optical components and

For this image taken in British Columbia, a 360mm focal length was obtained by combining a 180mm lens with a 2x teleconverter.

A teleconverter makes it convenient to change a standard focal length lens into a short telephoto. A 2x extender was used to photograph this group of fall trees in the Canadian Rockies.

the alignment around the optical axis may suffer. Bayonet mounts, which are usually used to combine the two, require some play so the centering of the combination of the lens and converter may not be as good as it can be in a high quality telephoto lens of a longer focal length. Because of the mechanical tolerances in the bayonet mounts, the image quality may also vary from one lens/converter combination to another, even if both the converter and the lens are of the same type and make.

● **Your Own Quality Tests**

As MTF diagrams are of limited practical value to the photographer, you may want to perform your own film tests. You can use lens test charts for that purpose, but a newspaper will work just as well. Be sure to select a section with fine detail and sharp outlines. While brick walls are often chosen as subjects for outdoor lens tests, they lack outlines and contrast. An old building made from stone or weathered wood is a better choice. Other points that you must consider are:

1. The test target must be absolutely flat.
2. The image plane must be parallel to the test target.
3. The test target must be lit evenly and identically for each lens.
4. If you compare different focal length lenses, each lens must cover the same size area, which means they must be used at different distances.
5. Eliminate any possibility of camera motion.
6. Make the test with the aperture wide open and somewhat closed down.
7. If you plan to use the lens for both long-distance and close-up shots, you may want to make the test at long and close distances. Also, keep in mind what the lenses are designed for. Because retrofocus type wide-angle lenses without floating lens elements achieve the best image quality at long distances, the test should be performed at longer distances.
8. Test a zoom lens at different focal length settings.
9. Use a sharp film, negative, or transparency with a low sensitivity (ISO 25 to 100).
10. Each negative or transparency must have the same exposure and must be developed identically. When evaluating the results, look at the actual negative or transparency. Never evaluate prints made from a negative or slides projected onto a screen, as several factors can distort the results. Evaluate the center and the corners of the image.

The aperture was closed down completely to f/22 for maximum depth of field from the front post to the rear window. Quality lenses do not produce any objectionable unsharpness at the minimum lens aperture.

The Loupe for Image Evaluation. For evaluating the effectiveness, composition and impact of 35mm and medium format images, it is nice to have a loupe that allows you to see the entire image without having to move the loupe. Such a loupe must be of the highest quality to give an image that is sharp from corner to corner. If not,

the image evaluation may become more distracting than useful. Such loupes must be expensive, especially for the medium format, and are likely to be a lower magnification.

To evaluate the sharpness of the image, however, it is really not necessary to see the entire image at once. It is easy to move the loupe to different areas of the negative or transparency—the center and the corners, for example. Since we are only evaluating a small section of the image, such a loupe need not have top quality over the entire viewing area. A high quality loupe with several lens elements is highly recommended, however, if only because it makes your images look so much better and therefore makes image evaluation more enjoyable.

A loupe that covers a smaller area can also have a higher magnification. I personally prefer a loupe with an 8x or 10x magnification. It allows me to see grain and sharpness differences between films, clearly shows the sharpness differences at various distances, and whether an unsharpness is caused by camera movement or by inaccurate focusing.

● Quality with Enlarging Lenses

Image quality is always determined by the weakest link in the chain. On a black and white or color print, the enlarger and the enlarging lens is part of this chain. It makes no sense to produce images with a high quality camera lens and then sacrifice that quality when the print is made.

Since enlarging lenses do not need a focusing mount, flash synchronization, or shutters, they are mechanically simpler and therefore cost less than

My own evaluation of image quality is done with a loupe that only covers part of the original but has a 10x magnification.

a camera lens. Enlarging lenses, however, must match the quality of the camera lenses. They must produce a sharp image from corner to corner, even with the aperture wide open. Get as much information as you can about the optical specifications and quality of

only be as good as the projection lens and the projector's illuminating system. The projection lens can be a fixed focal length or a zoom lens. The latter is convenient when the projector is used in different locations. If you decide on a zoom lens, check its image

Enlarging lenses, however, must match the quality of the camera lenses.

any lens you are considering straight from the manufacturer. Don't try to save money on an enlarging lens if you work with a high quality camera.

● Quality of Projection Lenses

Everything that has been said about enlarging lenses applies to projection lenses. The image on the screen can

quality carefully at all focal lengths; be sure to check the evenness of the illumination from corner to corner at all focal lengths. This is important since a darkening in the corners can be very distracting in a projected transparency. Because a darkening in the corners can also be caused by the projector's illuminating system, it is necessary to

A good projection system must project transparencies without any light fall off in the corners. Such darkening becomes distracting and objectionable on the screen.

investigate not only the quality of the lens but the quality of the illumination system as well.

The illumination system usually consists of a projection lamp with either a built-in mirror or combined with a mirror and one or several condenser lenses. The condenser lenses are necessary to concentrate the light coming from the lamp evenly over the entire area of the transparency and ascertain that the light goes through the lens without any brightness falloff in the corners. Strictly speaking, the condenser and projection lens must be matched to each other for the best screen illumination. This fact is somewhat more important in the medium format field, where the different focal length projection lenses may be supplied with a condenser matched to that focal length.

For corner to corner image sharpness, the mounted slide in the projector must be perfectly flat. This is not necessarily the case when slides are cardboard-mounted. Such a slide will bulge when exposed to the heat from the projection lamp and move in and out of focus on the screen. While automatic focusing adjusts for this, the change in sharpness can detract from the enjoyment of the projected image.

Glass mounting eliminates these problems. To enjoy the visual impact of medium format slide projection, the slides must be glass-mounted. In a projector designed mainly for glass-mounted slides, the slide channel can be made more precise so that every transparency falls into the exact same position, eliminating sharpness differences and assuring perfect positioning of images in a multi-projector show.

The slide that is in the projection gate must be kept cool. In addition to a fan, the heat from the projection lamp is usually reduced either by a heat-absorbing filter or by dichroic mirrors. Dichroic mirrors let the infrared heat radiation go through the mirror and reflect only the light, without a reduction in the illumination. Heat-absorbing filters reduce the amount of light and often also change the color of the light.

● **Relative Illuminance**

With every lens, the corners of the image receive somewhat less light than the center. Some of the light loss, especially on standard and longer focal length lenses, is caused by the lens design. On some lenses, especially telephotos, the diameter of the front lens element may have been reduced somewhat from what it should be for the purpose of reducing the size and weight of the lens. On other lenses, especially the wide-angle types, the major loss of light is caused by physical limitations in the lens barrel. Light rays that enter the lens at steep angles, as they do on short wide-angle lenses, may be cut off by mechanical components in the lens barrel. This so-called mount vignetting can be reduced by closing down the aperture.

Even if such physical limitations do not exist, there is darkening by natural light falloff. The aperture and/or shutter opening in the lens is smaller for light rays that enter at an angle than for those that enter straight from the front. You can visually convince yourself of this fact by holding a round object, such as a filter, about a foot in front of your eyes. If you look through the filter from the front (90° to the

surface of the filter) you see a large, full circle. When tilting the filter, you no longer see a full circle, but an elliptical shape that is greatly reduced in size. This obviously happens even without lens elements and therefore has nothing to do with lens design.

Vignetting or darkening of the corners occurs with wide-angle and extreme wide-angle lenses on any camera, and especially when combined with shift control or when used on panoramic cameras. Corner illumination is always improved—but not necessarily eliminated—by stopping down the lens.

The darkening can be made less noticeable or eliminated completely by reducing the illumination that goes to the center of the image. This is done with center gray filters that are placed in front of the lens. They even out the difference between the center and corner illumination but also reduce the light that reaches the image plane. Exposure must be increased, usually by 1 or 1½ f-stops.

Some lens manufacturers publish the data for relative illuminance. Like MTF diagrams, the illuminance is

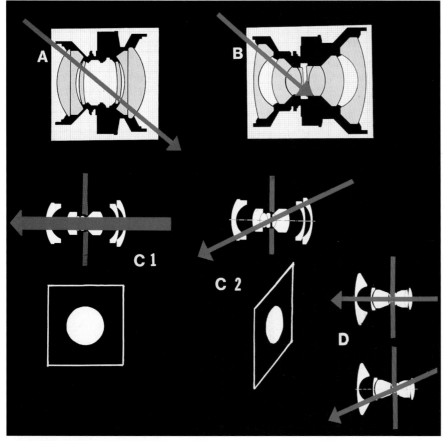

Left: Light rays entering a lens at a steep angle may be cut off by components in the lens barrel (B). Light coming from an angle is further reduced as these light rays have to go through the elliptical shape of the aperture (C2), which is smaller than the full, round shape for the light rays coming from the center (C1). The difference in illumination between center and corner is reduced by closing down the aperture (D). Below: A center gray filter used with the 30mm extreme wide-angle lens produces even illumination over the wide panoramic format of the XPan camera.

shown with the lens aperture wide open and somewhat closed down and also with the center of the image with full 1.0 or 100 illumination at the left and the distances from the center indicated on the horizontal axis. If the right end of the curve reaches 0.5, the light loss at the corner is equal to one f-stop, which is acceptable for general photography. For more critical work, you may want to improve the corner illumination by stopping down.

● Color Rendition

Color rendition has to do with the color of the image that is produced in the camera. Some lenses are known to produce a warmer image (more yellow) some a cooler one (more blue).

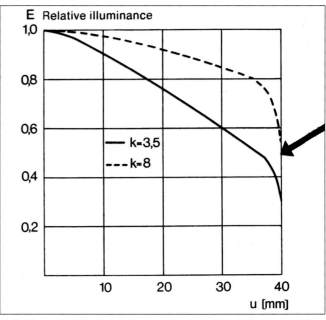

*Right: In an illumination diagram, the 100% illumination at the center of the field is shown at left with the distance from the center (in mm) indicated at the bottom, like in MTF diagrams. Stopping down a lens (dotted line) improves the corner illumination. At the position 0.5 or 50, the light loss is 1 f-stop. **Below:** This diagram shows the drastic improvement that can be obtained with a center gray filter (line c). Line "a" aperture at f/4.5, line "b" at f/11. Both without filter.*

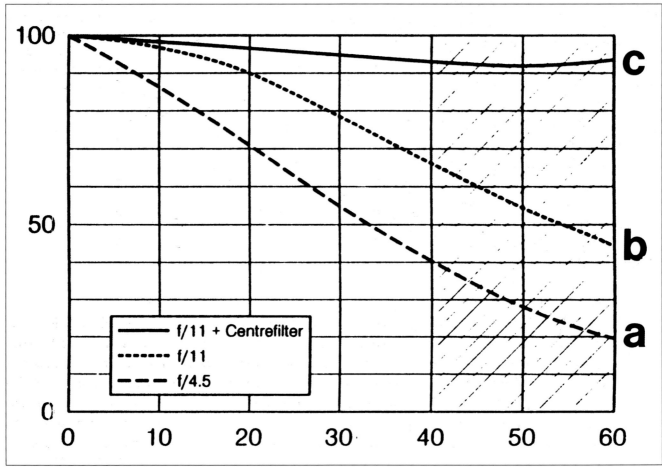

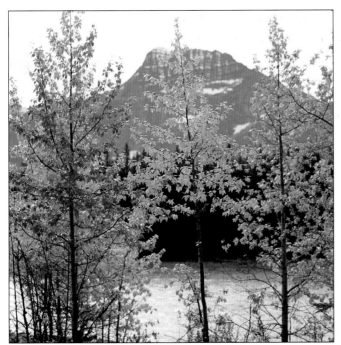
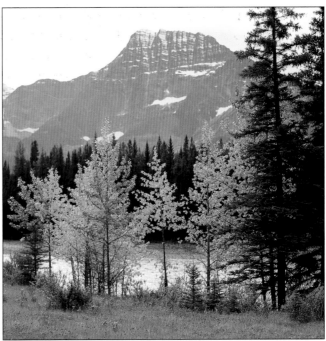

Color matching of the lenses is critical when different lenses are used to photograph the same subject. The slightest change in color rendition becomes objectionable. Individual multicoating of the different lens surfaces with six or seven layers can help in matching the color rendition of different lenses.

The color rendition is determined mainly by the glass used in the lens. Some types of glass used in modern lenses, such as dense flint types, are not absolutely clear but have a tint of one color or another and therefore act like a color filter. Color rendition is, to a minor degree, also affected and determined by the lens coating. Individual broadband coating of the various lens surfaces can help produce matched lenses.

Color rendition is not a major problem if we are only concerned with one image. Our eyes adjust easily when viewing individual images. It becomes a major concern, however, with sequences of images seen next to each other or one right after the other, as in slide shows or motion pictures. The slightest color variations become obvious, and are often objectionable to any viewer.

Since sequences of images are frequently taken with different focal

Good flare protection in the camera and lens and the use of a good lens shade are essential in backlighted scenes with bright reflecting areas.

length lenses, assuring accurately-matched color rendition in all lenses is extremely important. Unfortunately, color rendition can vary from lens to lens, and is most prominent when comparing lenses from different manufacturers. While it is possible to

match colors with filters, I highly recommended using lenses made by a single manufacturer on a camera system used for color photography. If different images, long shots and close-ups can be made with a single zoom lens, color rendition won't be a problem.

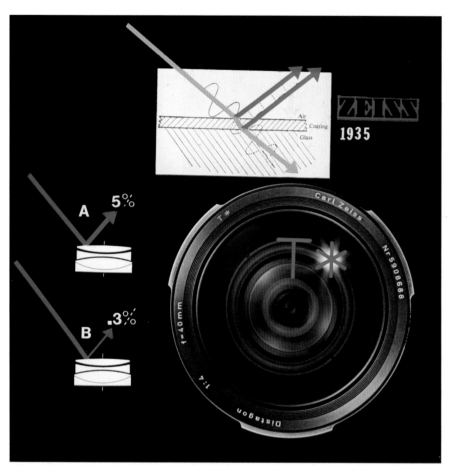

Lens coating, introduced by Zeiss in 1935, and multicoating reduces the amount of light reflected from a lens surface from 5% to less than 0.5% (with multicoating).

Multicoating (MC) reduces or eliminates reflections from the light that goes through the lens to form the image. Lens shades must be used to eliminate any light that hits the lens or the interior of the lens or camera body, but doesn't create the image.

● Lens Flare

Besides sharpness, a quality image needs a good contrast with clear high-lights and deep black areas. Images with a haze-like appearance, called flare, are unacceptable for most uses. Flare is likely to appear with any lens on any camera if the sun or a bright light source shines directly on the lens surface or when photographing against bright white backgrounds. Flare may also show up with some lenses when the subject or scene includes very bright areas, bright white skies, snow, sandy beaches, water with reflected sunlight, and the bright white backgrounds often used in fashion and high key pictures. Flare can be created by light reflections on lens surfaces, the interior of lens bar-rels, or camera bodies.

Coating and Multicoating. Coating and multicoating of lens ele-ments has reduced the potential for flare to a point where a well designed, multicoated lens can produce color and black and white images with good contrast even if they include bright, reflecting areas.

Lens coating was invented by Zeiss in the 1930s. The original sin-gle-layer coating reduced light reflec-tions from about 5% to about 1% on each glass/air surface. The single-layer coating was followed by a double-layer coating in 1939, a triple-layer coating in 1943, and multicoating in 1972.

Practically all modern camera lenses are multicoated. A multicoated lens has several layers of coating, each of a different thickness based on the wavelength of the different colored light rays. A good multicoating, with six to seven layers corresponding to the colors of the spectrum and applied

to every glass/air lens surface, reduces the amount of light that is reflected off each lens surface to less than 0.5%.

If a modern lens is not multicoated, it may have been omitted for a specific reason. One example is the Carl Zeiss 250mm Sonnar Superachromat. This lens was originally designed for NASA to be used also for infrared photography within the spectral range from 700nm to 1000nm. Multicoating would have absorbed the infrared radiation that is necessary for this type of photography. Since this lens, which has a single layer coating, is corrected into the the infrared range, it can be used for infrared photography without the need for a focus adjustment.

Light can be reflected not only by the lens surfaces, but also by the lens barrel as well as the inside of the camera body. Some camera and lens manufacturers pay special attention to this problem by designing and finishing the lens barrels and the inside of the camera to reduce or eliminate a possible flare problem from these surfaces.

A good multicoated lens produces images with superb contrast and without flare in the shaded areas.

A lens shade must also be used on overcast, foggy, or rainy days when the sky or the clouds are often extremely bright.

Lens Shades. While multicoating produces images with good contrast, it has not reduced or eliminated the need for lens shades except on lenses where the front element is deeply recessed so that the lens barrel acts as a lens shade. Lens shades serve a different purpose than multicoating. The purpose of multicoating, and the coat-ing of the interior of lenses and camera bodies with a dull black finish, is to reduce reflections from the light that actually goes through the lens to form the image in the camera. The purpose of a lens shade is to eliminate light that serves no purpose in creating the image from reaching the front of the lens, the inside of the lens barrel or the interior of the camera body. Lens shades are especially important when photographing toward light sources, against white backgrounds or bright areas in general (including overcast white skies, water, sand, and snow).

The regular round lens shades are compact and provide good, but not necessarily the most effective, shading.

Square or rectangular shades that conform to the image format are more effective. The longer the focal length of the lens, the longer such shades should be. It is wise to invest in the best shade for each lens, even if a different shade is needed for each lens. With zoom lenses, lens shades can only be as long as suitable for the shortest focal length of the lens. Therefore, they do not provide the most effective shading when such a lens is used at longer focal lengths.

In the medium format field, you find bellows shades, often called professional lens shades. The length of the shade can be extended to match the focal length of the lens, thus providing the best shading for all lenses. In addition, one and the same shade may be used with all focal length lenses.

● **Photographing Against White Backgrounds**

White backgrounds, which are commonly used in fashion and product photography and in high key portraiture, require special attention in reducing the potential for flare. The backgrounds selected for these shoots are often extremely bright, and any stray amount of light that reaches the image plane can have a disastrous effect on contrast in black and white or color images. You must be careful to keep any unnecessary light from reaching the image plane whether you work with film or a digital camera.

First we must consider the background area and brightness. Restrict the white background area to the minimum size that is necessary for the area coverage of the lens. Drape outside areas with a darker cloth. You may also

consider using a longer focal length lens that covers a smaller background area and therefore reduces the size of the white background.

Do not make the background brighter than necessary. A white background that is 1½ to 2 f-stops brighter than the subject usually shows up as

pure white. The background brightness can be measured and compared to the subject brightness either by holding an incident exposure meter or a reflected meter in combination with a gray card in front of the subject and the background.

We must also pay attention to the camera and lens equipment we plan to use for such pictures. Select multicoated lenses that are known for low flare characteristics (if this information is available), and use them without teleconverters. The quality and effectiveness of the multicoating is not necessarily determined by the number of layers. A multicoating with six or seven individually placed layers of coating on every glass/air surface within the lens can be considered an excellent solution. The six or seven layers must have different thicknesses based on the wavelength of the different colors within the spectrum.

The flare characteristics of a lens are not determined only by the multicoating, but also by the lens design and finish of the interior of the lens barrel, which must minimize the amount of light that is reflected and prevents whatever light may be reflected from reaching the image area. Some camera manufacturers also

design the inside of their camera bodies for the same purpose, and/or finish the inside surfaces with a special dull, black coating to eliminate or reduce the potential for light reflection.

The multicoating and the special designs and finishes in the lens and camera body reduce flare caused by

We must go a step further and reduce, or hopefully eliminate, unnecessary light.

the light that forms the image in the camera. We must go a step further and reduce, or hopefully eliminate, unnecessary light. This is accomplished with the lens shade. A lens shade is essential even with the best multicoating and flare reducing camera and lens designs because the shade serves a completely different purpose.

Using Lens Shades Most Effectively. For photography against white backgrounds with any camera and any lens, you must use a lens shade that prevents all (or at least most) of the light reflected from the background from reaching the lens. A shade that conforms to the image shape, either rectangular or square, is better than a round type. Keep in mind all lens shades, even if made for a specific lens of a specific focal length, are designed for the lens focused at infinity.

When focused at closer distances, the angle of view of the lens decreases and the shade no longer provides maximum shading. The differences can be quite dramatic with lenses that focus at close distances (macro lenses), when the bellows on large format cameras are extended, or when lenses are used in combination with extension tubes or bellows for close-up photography on any camera.

The professional lens shades are available for some medium format cameras and should definitely be considered for photography against white backgrounds. The bellows on such lens shades can be extended more or less depending on the focal length of the lens. While professional shades are

which the shade is designed. Doing so, however, also includes a larger portion of the white background, which may increase the potential for flare.

Extending the lens shade to the point where it matches the angle of view of the selected focal length setting is a better solution. This can be

In lenses with distortion, straight lines appear curved near the edges. . .

somewhat bulky, they provide the best possible flare reduction in all photography, not only when photographing against white backgrounds. The bellows on such a shade is extended to the focal length mark engraved on the rail that corresponds to the focal length used for the picture. While the engraved extensions are satisfactory for general photography, you must realize that they are based on photography at infinity and do not provide optimum flare reduction when the lens is focused at closer distances or when used together with extension tubes or bellows for photographing small products—jewelry, for example—against white backgrounds. You may want to extend it further based on a test described later in this section.

Shades on zoom lenses may be satisfactory at the wide-angle position, but not at longer focal length settings or when the lens is used in the macro position at any focal length. Such shades serve little purpose at longer focal lengths—especially on lenses with a long zoom range where the angle of view is much smaller than at the shortest focal length. You may possibly improve the effectiveness of the lens shade by photographing at the shortest focal length of the lens for

done by attaching black paper or thin cardboard to the shade completely surrounding the round, square, or rectangular shade. First, determine how long this "extension" should be. The suggested approach below applies to any camera and can also be used to determine the maximum extension on a professional lens shade when photographing at closer distances.

A Polaroid test is the easiest (though somewhat costly) method if the camera will accept a film magazine for Polaroid film. Make sure that the lens is focused at the desired distance and set to the shooting aperture. A second procedure is possible with any camera where you can look through the lens from the image plane (any camera where the back cover can be opened or the film magazine can be removed). Complete the following steps:

1. Open the rear cover or remove the film magazine.
2. Cover up the film area with tape or thin cardboard except for a small opening (about 3 mm) in one corner, preferably one of the upper corners. A special cover is available for one medium format camera for this very purpose.

3. Open the focal plane or lens shutter (in combination with the rear curtain in some cameras), using the T or B setting and a locking cable release.
4. Close the diaphragm to the aperture that will be used for the picture and focus the lens at the subject distance.
5. Point the camera at a bright subject and place your eye behind the opening. Tilt and turn the camera until you see the exit pupil, which is in the shape of the aperture if there is no vignetting.
6. Extend a professional shade, or lengthen a regular shade with cardboard to the point where vignetting just appears in the image of the exit pupil. If a professional lens shade is extended to the maximum and no vignetting is visible, you can increase the effectiveness by placing masks in front of the lens shade's frame.

Once you have established the maximum flare reduction for a specific lens, note the proper settings or length of a lens shade addition so you need not make new tests when the same lens is used at more or less the same distances and aperture settings.

● **Lens Distortion**
Lens distortion refers to the lens's inability to record straight lines as straight lines over the entire film area. In lenses with distortion, straight lines appear curved near the edges, either outward in the corners (pincushion distortion), or inward (barrel distortion). In optical language, distortion is the spatial relationship of different image points on the film as compared

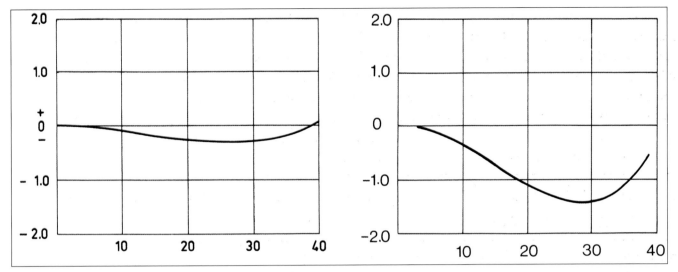

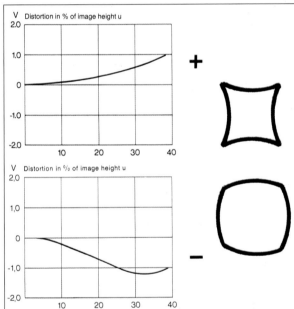

Left: In a distortion diagram, the amount of distortion is shown in percentage values of the relevant image height (figures +2.0 to -2.0 on the left side). The distances from the center are indicated on the horizontal axis (0 to 40mm in a medium format diagram). A curve that goes in a positive range indicates that the image point at the edges is further from the center than it should be, so the lens has pincushion distortion. A curve going into the negative area indicates barrel distortion. *Above:* The distortion curve for an optically true wide-angle lens (Biogon, left) shows the superiority of such a lens over a retrofocus type (Distagon, right). A distortion value of around 1%, however, is still considered very good, and acceptable for most architectural work.

to those in the subject. The deviation depends on the distance from the optical axis and is expressed in % in distortion diagrams published by some manufacturers. A 1% distortion on a 56 x 56mm image means a deviation of .28mm. Distortions up to 0.5% or even 1% are not noticeable in general photography. This, however, depends on where the distortion appears within the image and whether it is continuous (the curve in a distortion diagram going in one direction only) or not continuous (when the curve is bent going in different directions within the negative or positive area).

In some photographic fields, such as portraiture, the degree of distortion correction is less critical than in architectural, product, and scientific photography. Lenses used in these fields should not display any noticeable degree of distortion. Lens distortion is the same at all lens apertures.

The inability to produce an image with perfectly straight lines is the only distortion caused by the lens and the lens design.

● Other Image Distortions

Various other effects that appear in photographic images are called distortions and are frequently blamed on the lens. We often refer to distortion when a subject, or part of a subject, close to the camera appears too large in relation to the rest of the subject or scene. A typical case is a portrait where the nose appears too large in relation to the rest of the face. We often blame the lens, usually the wide-angle, for this problem because this effect is more likely to appear in wide-angle pictures. The effect, however, is not the fault of the lens, and distortion is not the proper name for it.

Foreshortening. Foreshortening is the proper term for the effect that is

mentioned above. It is not caused by the lens, but rather by the camera being too close to the subject. It is a problem of perspective and results from the shooting distance. At close distances, the difference in size between subjects closer and further from any camera lens is exaggerated. The foreshortening shows up more often in wide-angle pictures only because wide-angle lenses are more likely used at close distances. Foreshortening is reduced by photographing from a longer distance, if necessary, with a longer lens to maintain the size of the foreground subject. In a portrait you must be at least three feet (1 meter) away from the person to avoid this effect, regardless of the lens used on the camera. Short telephotos are your best option for a head and shoulder shot.

Slanted Verticals. Slanted vertical lines are often referred to as distortion and this effect, too, is sometimes blamed on wide-angle lenses. The slanted verticals are caused by tilting the camera, which places the image plane at an angle to the subject. With wide-angle lenses, the slanting is enhanced. Vertical lines appear vertical and parallel to each other when the

To avoid visible foreshortening in portraits, shoot from a distance of at least 3'. Example taken from 4' with 120mm lens (about 80mm in 35mm) on the 6cm x 6cm medium format.

appears egg-shaped in the corner of the picture. A person's face is distorted, as often seen in banquet, news and documentary pictures made with

The objects at the sides or corners of the image appear wider than those in the center.

image plane (on any camera, with any lens) is parallel to the subject plane.

Wide-Angle Distortion. Another type of distortion occurs when three-dimensional subjects are photographed with wide-angle lenses. The objects at the sides or corners of the image appear wider than those in the center. A perfectly round chandelier

wide-angle lenses. Because this effect is obvious and objectionable in pictures taken with wide-angle lenses, it is called wide-angle distortion. Despite the name, the effect is not caused by the lens. It happens in pictures taken with even the best, distortion-free wide-angle lenses, and it also happens in pinhole cameras that have no lenses.

The major cause of wide-angle distortion is the flat image plane in the camera. Based on pure geometry, three-dimensional objects appear elongated when projected at an angle on the flat plane.

There is a second reason why three-dimensional objects at the sides of images appear distorted: the wide-angle lens sees objects at the perimeter of the composition from a different angle than those in the center. In a group of people, for example, the lens takes in the front of the faces of people standing in the center of a composition but "sees" the side of the heads of those standing at the left and right.

Subjects that we normally see with straight lines should be recorded with straight and parallel verticals (Quebec City).

Slanted verticals can make an image more dynamic when they are used as a background.

In group or product pictures, distortion can be reduced by turning the subjects so they face toward the center of the lens. The lens now sees each one from the same angle. In situations with nonmovable objects, such as a room interior, try to make the composition so that objects that may easily look distorted do not appear on the edges or corners of the frame.

Wide-angle distortion happens only with three-dimensional, not flat, subjects. It does not occur, for example, in copy work.

Left: Wide-angle distortion rendered these decorative balls on the right and left as egg-shaped. *Top, Right:* Three-dimensional subjects, like the cups pictured here, appear distorted because the wide-angle lens "sees" subjects at the perimeters of a composition from a different angle than subjects placed in the center. *Bottom, Right:* The distortion in people or products can be reduced if the subjects on the sides are turned toward the center of the lens (R) so the camera sees them from the same angle as those in the center (C).

4

IMAGE QUALITY

● Quality-Determining Elements

Achieving the ultimate image, one free from distracting technical faults, must be the goal of every photographer. Because today's black and white and color films are incredibly sharp, and professional digital cameras can achieve such high resolution, every photographer in every field of photography must be extremely critical about everything that determines image sharpness. The image sharpness in any camera can only be as good as the weakest link in this chain, or most likely is even worse than the weakest link.

If your images are not acceptably sharp, don't place all of the blame on the lens. There are many other factors that affect the sharpness of the image created in any camera, including:

1. The level of precision in which a lens mounts on the camera
2. The accuracy in the distance to the image plane
3. The precision in the alignment of the mirror and the focusing screen in an SLR camera
4. The film flatness in a film camera
5. The quality of the camera body after producing thousands and thousands of exposures

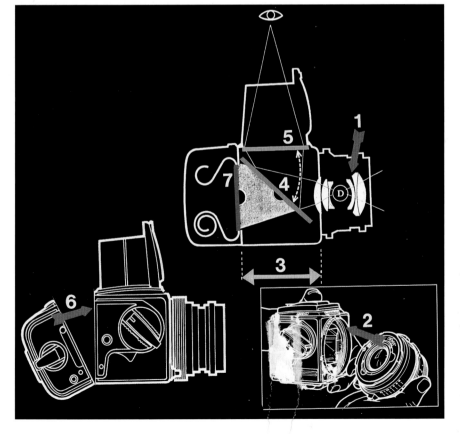

The image quality is determined not only by the lens design (1) and lens construction, but other factors, such as the precision in the lens mount (2); the construction and exact dimensions in the camera body (3); and the mirror and focusing screen position in an SLR camera (5). Image quality is also determined by (6) the precision in the magazine mounting if magazines are interchangeable and (7) the flatness of the film in a film camera.

6. The resolution of the film or image-forming element in a digital camera
7. The exposure
8. The photographer's approach in operating the camera, especially the focusing accuracy and camera steadiness

● Film Choice and Sharpness

All the films available today are incredibly sharp compared to those of yesterday and will undoubtedly improve in the future. Today's higher sensitivity films, such as ISO 400 or even ISO 800, produce a sharpness that was only possible with ISO 100 a few years ago. However, despite the gains made, lower sensitivity films still yield sharper images with less visible grain. Provided they are fast enough for the lighting situation and your desired photographic approach, they should be the film of choice whenever ultimate image sharpness is important.

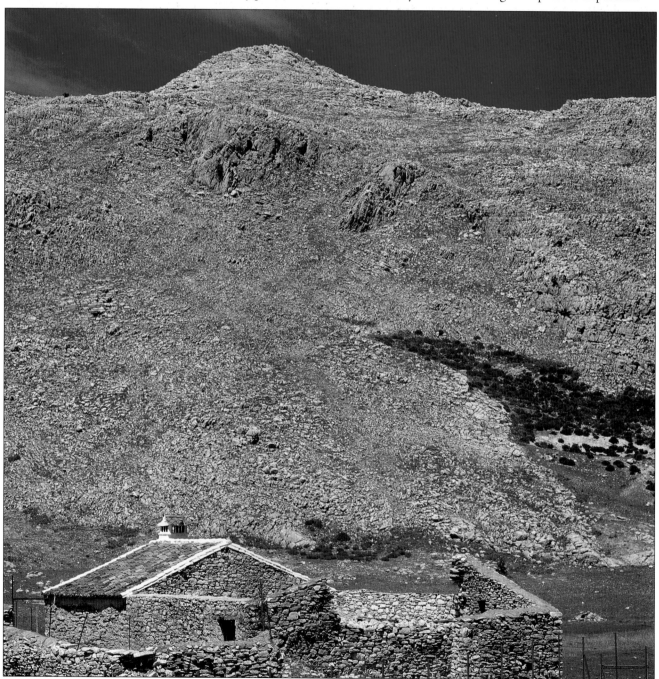

This photo is a good example of the superb image sharpness that is possible on today's high resolution films. Obtaining this quality requires careful attention to everything that affects image sharpness, from the selection of the camera and lens to critical focusing and perfect camera steadiness (180mm Carl Zeiss Sonnar).

The resolution that is possible on today's films is vividly illustrated in the 10x blow-up (left) from one of the postage stamps on the full 2¼" transparency (right).

When the lighting conditions are unpredictable, as in much of location and travel photography, carrying films with different sensitivities is advisable. Switching from one film sensitivity to another at any time without having to finish the roll of film in the camera is highly advantageous.

Such a change of film is possible at any time and practically instantly with medium format cameras that offer interchangeable film magazines, not just interchangeable film inserts.

Some 35mm cameras also offer film interchangeability, but only by rewinding the film, removing it from the camera, and reloading the camera—obviously a time-consuming process. 35mm photographers usually solve the film changing problem by carrying two camera bodies loaded with two different films. That works— at least in handheld photography (as for photojournalistic work)—but switching cameras is highly impractical and time-consuming when working from a tripod.

● Image Plane Flatness

Image plane flatness is not a problem with digital cameras. When the image is recorded on film, maximum sharpness over the entire image area is achieved only if the film surface in the camera is sufficiently flat. You cannot reap the benefits of the highest quality lens if the image plane is not flat.

Film flatness in any camera depends mainly on the precision in the film plane design and pressure plate. It

medium format manufacturers make special attempts to assure the best possible film flatness; for example, by adjusting the rollers individually in each magazine to the thickness of the film.

The problem in the medium format field is further increased since the films have different thicknesses. 120 roll film has a paper backing that makes this film much thicker than a 220 film without paper. Film channels

Good film flatness is more difficult to accomplish as the film size increases. . .

is easier to accomplish good film flatness in a smaller format (35mm or APS system), but variations exist even in these film formats.

Good film flatness is more difficult to accomplish as the film size increases, as in medium format cameras. In medium format cameras, film flatness is determined mainly by the size, arrangement, and adjustment of the film rollers in the magazine. Some

and pressure plates must be adjusted differently for the two films, whether this is done in a magazine built for 120 and 220 film or in magazines that are specifically and exclusively built for either 120 or 220 film, not for both. In either type, 220 film without paper backing likely has better flatness, a quality that need not be considered for general photography with a good medium format camera system.

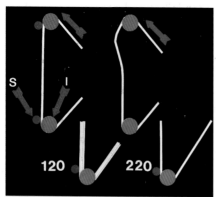

Perfect film flatness (left, top) is necessary in any camera. Special designs, such as carefully adjusted rollers (S and I) may be needed in medium format cameras, especially because 120 roll film is much thicker than the 220 film often used in these cameras.

Film flatness in a medium format camera can be inferior on the second frame taken on a roll of film that has been left in that position in the camera for some time. This is because the second picture falls on the part of the film that has been curved over the rollers while the film was left in the camera. In any camera, the film is likely to be flattest when it is advanced to the next frame just before the picture is taken.

● Mirror Motion in SLR Cameras

On all SLR cameras, the mirror swings up and down every time we take a picture (unless it has been permanently locked up). After thousands of exposures, it is possible that the mirror on any SLR camera does not go back to the same original position, which is very critical for accurate focusing. Have the mirror alignment checked once in a while by an authorized service station.

● Evaluating Image Sharpness

A careful image evaluation under a good magnifying glass can often reveal the cause of unsatisfactory sharpness. If the center of the image is sharp but the corners are not, then the problem is probably within the lens itself. On the other hand, the unsharpness may also be due to choosing a lens designed for the wrong purpose. This can be the case when a retrofocus type lens without floating lens elements is used for close-up photography or a large format camera lens is used at a large aperture. If bright areas have an unsharp edge or streak on one side, we can assume that camera or subject motion was the culprit. If the sharpest point within the image area varies from one image to the next, we may have a problem with film flatness.

If the sharpest point in the image is not in the subject area at which you focused (the eyes in a portrait, perhaps) but is in front or behind the focused distance, we have a focusing problem. This may be the fault of the photographer or the equipment. If the sharpest area is always in the same plane, for example, always in front of the focused distance, the mirror or focusing screen may be out of alignment or the film plane distance may be wrong. If the position of the sharpest area is sometimes in front, sometimes in the back of the focused distance, the problem is more likely rooted in focusing accuracy.

The above problem may also be caused by a lens that has a focus shift, meaning that the point of focus shifts as the aperture is closed down. The distance setting, made by visually focusing the image on the SLR focusing screen at the normally full open aperture, is not correct for the smaller aperture at which the picture will be made. In the image, the point of maximum sharpness is not where it was on

Camera motion problems are indicated by double images or streaks from the highlights.

A viewfinder on an SLR camera must provide the photographer with a sharp, magnified image of the focusing screen and any electronic data displayed next to or above the focusing screen.

the focusing screen. This is not likely to happen on quality lenses, except perhaps on extremely fast 35mm lenses. If a focus shift happens, it is often not objectionable as the increased depth of field at the smaller aperture compensates for it.

● Viewing and Focusing

Depending on the camera, viewing and focusing may be done with an optical viewfinder (perhaps in combination with a split-image rangefinder), an LCD viewer (if it is the digital type), or a finder/focusing screen combination (on an SLR camera). The viewfinder may be used in composing the image (such as in a point and shoot camera or a camera with auto-

matic focusing); it may also be used in focusing the image.

Viewfinders also magnify the image of the focusing screen. Because a higher magnification may help you to focus quickly and more accurately, it is worthwhile to consider the finder magnification when studying camera specifications.

In serious photography, the main function of a viewfinder on an SLR camera is to provide a sharp, magnified image of the focusing screen. This is possible only if our eyes can focus at the distance at which we see the image of the focusing screen through the viewfinder. This distance varies from one camera to another and may also vary from one type of finder to anoth-

er if the camera system has inter-changeable finders.

● Determining Focusing Accuracy

To determine whether your eyes will see a sharp image of the focusing screen in an SLR camera, perform this test: Remove the lens from the camera so you see nothing but the focusing screen. Look through the viewfinder and check whether lines on the focusing screen appear really sharp to you. Do this several times. In between each test, look at a distant subject for a few seconds to relax the eye. If the screen pattern appears really sharp, focusing should not be a problem.

If your viewfinder has a built-in diopter correction control, turn the control to the position at which it provides the sharpest image of the screen. Do this several times and, if possible, lock it at this position. If the finder does not have a built-in diopter correction, the manufacturer may offer correction lenses or eyepieces to match your eyesight.

You may want to follow up the first test with a second one with a lens on the camera. Point the camera/lens at a subject with fine detail, turn the focusing ring to determine whether you can actually see the fine details, and check whether you can see, without a doubt, when the lens is focused accurately.

Perform this test a few times to see whether you always end up at exactly the same setting on the focusing ring. Perform the test with different lenses if you have them (especially with wide-angles), and also at lower light levels where focusing always becomes more of a problem.

If you plan to wear glasses for viewing, be sure to perform both tests with your glasses on. Similarly, if you wear bifocals and plan to wear them for viewing, perform the test through the part of the glasses that you plan to use. The area for long-distance viewing is usually more suitable and is more likely to provide a sharp image in the finder. Most cameras

image, especially in low light levels, brightness alone does not help in accomplishing focusing precision. Precise focusing needs a high resolution in the focusing image that allows you to see fine detail within the subject.

Superb focusing accuracy has been accomplished on some modern screens with a focusing surface that is

achieved, rangefinder focusing seems to be preferred by many photographers and seems to produce more accurate focusing for others. Keep in mind that the image in the rangefinder area always looks sharp. The fact that the rangefinder area must be aimed at the main subject, a straight line within the main subject, or in another subject at the same distance, may be a drawback when you must work fast.

Astigmatism is seldom a factor in viewing through a camera viewfinder.

today have what is called high eyepoint eyepieces. Such an eyepiece should allow you to view and focus with or without eyeglasses and always see the entire finder field. Astigmatism is seldom a factor in viewing through a camera viewfinder.

Whether you want to remove the glasses or leave them on when photographing must be your choice. While I realize that removing glasses is a nuisance, especially when you need them for reading the figures on the camera and lenses, taking them off yields better camera steadiness in handheld photography. I hang my glasses on a chain so they can be dropped easily.

Focusing Screens on SLR Cameras. Focusing screens for better SLR cameras come in different types such as plain screens, screens with split-image rangefinder or microprism, or a combination of the two. The choice of screen must be your personal decision. Test the various screens with your lenses and with your preferred subject matter. Seriously consider not only the image brightness on a screen but also the sharpness of the image. While a bright image on the screen is helpful when composing and evaluating the

practically invisible, making it obvious when the image is "jumping in and out of focus" when the focusing ring is rotated. The Acute matte type made by Minolta is, in my opinion, a superb focusing screen. With a screen like this, you will probably find that accurate focusing can be accomplished without a microprism or a split-image rangefinder. This, however, is your personal choice.

Focusing with a Split-Image Rangefinder. With a split-image rangefinder, whether it is part of an optical finder or focusing screen, the subject is in focus when a straight line running across the dividing line appears unbroken. Since it is quite evident when the point of proper focus is

In an SLR camera, the primary limitation of using a split-image rangefinder in focusing involves lens apertures. When the aperture of the lens is smaller than f/4 or f/5.6, one side of the split-image rangefinder field blacks out. Such a screen should not be considered if you use lenses with a maximum f/5.6 or f/8 aperture extensively. When lens apertures are f/4 or larger, both fields of the split-image rangefinder are clear only when your eye is in the optical axis. If one of the fields is blacked out, move your eye slightly up, down, or sideways.

Focusing with a Microprism. The microprism center area consists of many tiny prisms that split lines if the lens is not focused at the proper distance. The image jumps readily and rapidly into place, especially compared

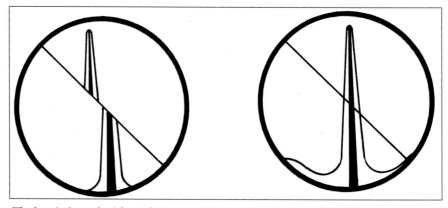

The lens is focused with a split-image rangefinder when a straight line appears unbroken across the split (right).

Left: The best camera steadiness is achieved with any camera when the hands press the camera firmly against the eye and forehead. Right: Properly held and carefully released, a handheld camera, even a medium format type, produces excellent image sharpness .

to the old ground-glass screens. Microprism focusing also has limitations regarding lens apertures that are similar to those aperture-related limitations described above.

● **Camera Motion**

For the ultimate image sharpness, the camera must be perfectly stationary when the exposure is made. Press the release slowly, perhaps press it halfway to the ready point so only slight additional pressure is needed to activate the shutter. When working on a tripod, lock up the mirror and use a cable release at slower shutter speeds or with longer lenses.

● **Viewfinders in Handheld Photography**

The danger of camera motion in handheld photography is reduced when the hands press the camera and finder in one direction (against the photographer's eye and forehead), and the eye, pressed against the viewfinder eye-

piece, pushes in the opposite direction. The viewfinder eyepiece becomes an important component for steadying the camera. Placing a large rubber eyecup around the finder eyepiece can help. For handheld photography, you may also want to consider removing your eyeglasses as they do not provide firm contact with the camera.

Handheld photography, properly done, can produce excellent image sharpness, even with compact medium format cameras. Shutter speeds must be relatively short. A good rule is to use a shutter speed not longer than the inverse of the focal length of a lens, $1/100$ second with a 100mm to 120mm lens, $1/60$ second for a lens of 50mm focal length. Many photographers use longer speeds when needed. The required short shutter speeds require larger lens apertures and therefore provide less depth of field. The limited choice in depth of field is, in my mind, the main limitation to handheld photography.

● **Working with a Tipod**

A tripod, properly used, can ensure camera steadiness in practically every picture-taking situation. The danger of motion produced by a single lens reflex camera is reduced or eliminated by locking up the mirror.

There are two theories to working with a tripod. In the "free-standing theory," the photographer avoids any body contact with the tripod or camera. The camera is released with a cable or remote release. Camera steadiness is then completely dependent on the steadiness of the tripod. This approach must be used when exposure times are longer than $1/2$ or 1 second.

In the second method, either both hands are on the camera or one hand is placed on the camera, the other on the tripod. Both hands press the tripod and camera toward the ground. The tripod serves simply as an additional support. The camera can be released with or without a cable. At

shutter speeds up to ½ second with shorter lenses (somewhat shorter with longer focal lengths), this "tripod/ body approach" seems best. Properly applied, it produces absolutely sharp results, even with lightweight tripods.

● Exposure

The apparent sharpness of a film image is also determined by exposure. While this applies to images on both negative and transparency films, the difference becomes more obvious on color transparencies. A transparency that is properly exposed for the lighted areas, or perhaps even slightly underexposed,

washed out. Darker, shaded areas may not really look dark or black but have a gray haze reducing the contrast in the image.

The apparent sharpness of an image is greatly determined by its contrast, with a higher contrast image always appearing sharper. For maximum image sharpness, expose your images carefully. Base the exposure for transparencies on the lighted areas without worrying about shadow detail. If you try for details in the shade, the lighted areas will be washed out, and the transparency will lack the ultimate image quality. Following this

quently opt to project a transparency that looks a little dark on the light table. If I have two transparencies with different exposures, I usually pick the darker one for projection.

● Depth of Field

I have decided to discuss depth of field here, rather than in the "lens quality" section because lens design and lens quality have little to do with depth of field. Depth of field figures are calculated based on the focal length of the lens, and the lens aperture and depth of field scales and charts are made up from these calculated figures.

With any lens on any camera, there is a range in front of and behind the focused distance that is acceptably sharp and is known as the depth of field. At normal shooting distances, about ⅓ of the total sharpness range is in front of the set distance and ⅔ behind. At close distances, the ratio is more equal.

The apparent sharpness of a film image is also determined by exposure.

always looks sharper than one that is on the overexposed side. The main explanation is in the fact that an overexposed image lacks detail in the lighted areas and makes such areas look

advice is extremely important if you plan to project your transparencies. A properly exposed, or slightly underexposed transparency is usually visually more effective on the screen. I fre-

Left: Optimum image sharpness requires perfect exposure without washed out highlights in transparencies. With fill flash, as in this case, keep the flash exposure down to avoid washed out flesh tones. **Right:** *Transparencies must be exposed for the lighted areas, even if they include large shaded areas, as in this image taken in a marketplace in Cyprus.*

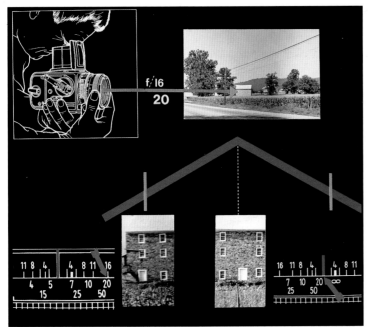

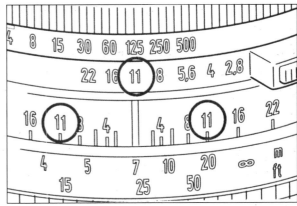

*Left: Depth of field is the range in front of and beyond the set distance at which the lens (at a specific aperture) produces acceptable sharpness. Only the subject at the focused distance is critically sharp. **Above:** The depth of field range is read on the focusing scale opposite the aperture value set on the lens. Distances may be engraved in feet and meters as seen here.*

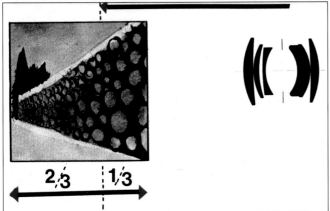

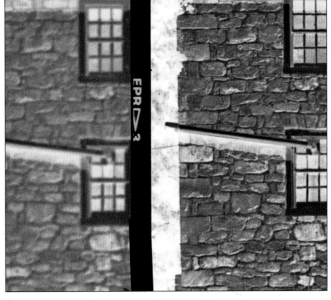

*Above: At longer distances, ⅓ of the total depth of field is in front of the set distance, ⅔ is behind. **Right:** Under a 10x magnification the difference in sharpness with the lens focused at the subject (right), and the acceptable sharpness at the end of the depth of field (left) but still within the depth of field range, is visible.*

At the focused distance, a subject point forms an image of a point. Beyond and in front of the focused distance, the image of the point becomes a circle of a certain diameter that increases in size as the image moves further from the focused distance. This circle, called the circle of confusion, determines the depth of field. The depth of field range is the range within which this circle still appears acceptably sharp to our eyes when the final image is a reasonable size.

Acceptably sharp does not mean critically sharp. Under critical evaluation of the original negative, transparency, or digital image under a good magnifying glass, you will undoubtedly become aware of the difference between critical and acceptable sharpness. You will find that the only subject that is critically sharp is the subject that is at the focused distance. Anything closer and further away is not as sharp—even if it is within the depth of field range. Subjects toward

the end of the depth of field range are blurred. Don't be shocked when you see the sharpness fall off within the depth of field range under the magnifying glass. There is nothing wrong with your lens, and it may mean that you have an exceptionally sharp lens where differences in sharpness become much more obvious. While lens design does not play a part in the calculation of the depth of field scales, we must acknowledge that, in visual examination, images taken with a very sharp

lens seem to show less depth of field than those made with a lens of inferior quality simply because the falloff in sharpness is more obvious.

We are more aware of this difference in sharpness today because of the superior resolution capability of today's films. This fact undoubtedly explains why critical photographers today often feel that their lenses do not have as much depth of field as they should based on the scales, or that the engraved depth of field scales are not correct. In a way, these photographers are right.

Depth of Field Charts and Scales. Depth of field scales were calculated many years ago when films had very low resolution figures. The charts have never been changed and brought up-to-date for today's much sharper films. Obviously, we are working with outdated figures.

In general photography, most of the images that are created based on these old depth of field figures are acceptable. For critical work you may not want to use the entire depth of field range. You may want to try to keep all the important elements within half of the indicated depth of field range or to stop-down the aperture two stops more than necessary for the desired sharpness range. If one specific subject or area of a subject needs to have maximum sharpness, focus on that subject. Don't rely on depth of field.

Depth of Field with Different Focal Length Lenses. You have probably heard that longer focal length lenses have less depth of field than shorter ones. This fact is correct, but only when the different lenses are used to photograph a scene or subject from the same distance. Used this way, the wide-angle lens covers a much larger area than the standard or telephoto. The three lenses create three completely different images. If the different focal length lenses are used to cover the same area, (with the wide-angle being at a closer distance, the telephotos being further away), all three lenses have exactly the same depth of field at the same aperture. Depth of field is then determined only by the lens aperture and the area coverage, the magnification.

Keep this fact in mind especially when you photograph a subject of a specific size—a head and shoulder portrait, or a product, for example. The magnification is predetermined and the depth of field at a specific aperture is the same no matter which lens you use. While the depth of field is the same, different focal length lenses can blur backgrounds and foregrounds to varying degrees. Subjects beyond the range of sharpness become more blurred as the focal length increases. For this reason, background sharpness may determine which focal length lens to use.

Depth of Field with Teleconverters. When teleconverters are used with any

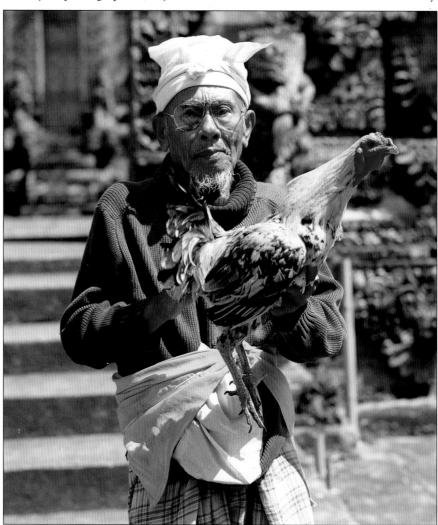

Depth of field is shallower in the medium format, used here with a 110mm lens, than in 35mm. This can be a great advantage as blurring backgrounds makes them less distracting.

lens, the depth of field scales engraved on the lens no longer apply since the focal length has changed. The depth of field now corresponds to that of the focal length achieved by the combination of lens and converter, for example, for 160mm when an 80mm lens is combined with a 2x converter and for an aperture of f/5.6 when the lens is set at f/2.8 (loss of two f-stops).

To obtain a fairly accurate idea of the depth of field range, you can use the depth of field scales on the lens as follows:

1. With a 1.4x converter read the depth of field opposite the aperture figures one stop larger than set on the lens, for f/8 if the lens aperture is set at f/11

2. With a 2x converter, read the distances opposite the figures for an aperture two stops larger than set on the lens—for f/5.6 if the lens is set at f/11.

Naturally, you can read the depth of field range on depth of field charts in the same fashion, reading the figures for apertures one or two stops larger than set on the lens.

Depth of Field in Different Image Formats. Depth of field is also determined by the image format in the camera. Recorded on a larger image area, as with a medium or large format camera in comparison to 35mm, depth of field is reduced at the same focal length and aperture. This difference is caused by the difference in the magnification. When covering an area of 4" x 5" (100mm x 125mm) with a 4" x 5" large format camera, the magnification is 1:1 with a depth of field of only about 2.5mm at f/11. Covering

A short telephoto lens set to the hyperfocal distance produced the maximum depth of field to infinity.

the same area with a 6cm x 4.5cm medium format camera means a magnification of only 0.4x with a depth of field of about 13mm at f/11. Doing the same with a 35mm camera, the magnification is only 0.2x with a depth of field of about 40mm. Therefore, there is less depth of field in medium format photography than in 35mm.

Hyperfocal Distance. Hyperfocal distance is often described as the focus setting that produces the maximum depth of field. While this is true, the statement might give the impression that the hyperfocal distance setting does something very special to your images. Not so. Hyperfocal distance is simply the focus setting on the lens that produces depth of field up to

infinity at the chosen aperture. If you want depth of field to infinity, the hyperfocal distance is the right approach.

You do not need a hyperfocal distance chart since most lenses are equipped with depth of field scales. Any lens is set to the hyperfocal distance when the infinity mark on the focusing ring is opposite the aperture marking on the depth of field scale that corresponds to the aperture that is set on the lens. If you want to know the hyperfocal distance, look at the distance opposite the index mark. The minimum depth of field distance is found opposite the corresponding aperture marking to the left of the index. This distance is always half of the hyperfocal distance.

While the hyperfocal distance setting will provide the maximum depth of field, and depth of field to infinity, keep in mind that those mountains at infinity will be acceptably, not critically, sharp.

● Depth of Focus

The term depth of focus is often erroneously used in place of depth of field by those who think the two are the same. No so. Depth of focus is the range in the image distances behind the lens that produces acceptable sharpness with a specific lens at a specific aperture. Depth of focus is extremely shallow, which is the reason why the precise positioning of the image plane is extremely critical in any camera and why perfect film flatness is of utmost importance in any film camera.

● Image Quality with Filters

In addition to serving as lens protection, filters can improve the effectiveness of many images. Although a filter is nothing but a plain piece of glass, it is an optical component through which light must pass. If the two surfaces of the chosen filter are not ground and polished to perfection, however, the filter can easily reduce the image sharpness.

If you work with high quality lenses, you should also work with high quality filters. This is especially important with filters that are used at all times such as the haze and UV types used for lens protection. These filters become a semipermanent part of the lens and must be made to the same degree of perfection as the lens. Using top quality filters is imperative if you plan to stack filters.

Filters for Long Telephoto Lenses. Filter quality is extremely important with long tele lenses, especially the high quality apochromatic types. The filters must be of the highest quality. A filter that is not perfectly flat will produce telephoto images that are outright unsharp. A poor quality filter may even make it impossible to focus the lens at infinity.

Ultraviolet Absorption. UV and haze filters used to be considered necessary for high altitude photography, for eliminating haze and the bluish cast in distant shots, and for reducing the blue cast on overcast days or in shady areas. While these filters still offer advantages today, their use and need is reduced. Most high quality lenses have some lens elements made from types of glass that absorb more UV rays than the UV filter ever did. In a sense, these lenses feature a built-in UV filter.

I have found that today's color films, in combination with modern quality lenses, do not exhibit an objectionable bluish cast in shaded areas or on overcast, foggy days. I have not used UV filters for this purpose for a number of years.

Do not expect a UV filter to improve your distant shots. Use a

Left: A high quality polarizing filter used on a 250mm telephoto. *Right:* Today's films, combined with high quality lenses, produce natural colors without objectionable bluish casts, even at high altitudes. In Switzerland with a 250mm lens.

polarizing filter for that purpose; it can produce miracles if the scene is sidelit.

● Selection of Close-up Accessories

Close-up accessories are used when the camera lens does not focus close enough to cover a small area. Most camera systems offer a choice of accessories such as close-up lenses (also known as Proxar lenses), extension tubes, and bellows. The choice of accessory depends mainly on the size of the area to be covered (the magnification), the lens to be used, and perhaps also on the desired camera-to-subject distance, and on the camera itself—whether it has interchangeable or fixed lenses.

Close-up Lenses. Close-up lenses are positive lens elements that are mounted in front of the camera lens like a filter. They can be used on cameras with fixed lenses or with interchangeable lenses of any focal length, as well as zoom lenses. Close-up lenses should always be as near to the front element as possible. If close-up lenses are combined with filters, mount the filter in front of the close-up lens.

Close-up lenses may be listed and engraved with their focal length or their diopter power like eyeglass lenses. Diopter is just another way of expressing the focal length of a lens. A lens with a one meter (39½") focal length has a one diopter power. A two diopter lens has a focal length of 50cm (19¾"), a three diopter lens 33.3cm (13"), and a 0.5 diopter's focal length is two meters (79").

You can combine two Proxar lenses. The power of the combination is obtained by adding the two diopter strengths. For example, a +1 and +2

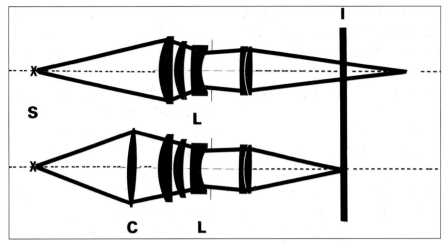

A subject (S) closer than the minimum focusing distance of the lens (L) forms its image behind the image plane (I) (top). A close-up lens (C) in front of the lens can bring the image onto the image plane (bottom).

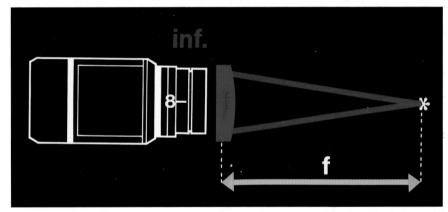

With the lens focused at infinity, a subject is in sharp focus when the subject distance, measured from the close-up lens, is equal to the focal length of the close-up lens.

close-up lens adds up to a +3 diopter lens with a focal length of 33cm (13").

Subject Distances. The diopter power or focal length determines the subject distance at which the lens produces sharp images. With the focusing ring on any lens on any camera set at infinity, a close-up lens always produces a sharp image when the subject distance, measured from the close-up lens, is equal to the focal length of the close-up lens, thus, one meter or 39½" with a one diopter lens, 79" or two meters with a 0.5 diopter type.

The above distances apply for the infinity setting. The focusing ring on the lens need not be at infinity while shooting but can be set at whatever distance produces a sharp image on the focusing screen. The above figures are therefore the maximum distances for each close-up lens. Close-up lenses do not require an increase in exposure.

Image Quality with Close-up Lenses. Adding a close-up lens is like adding a lens element to the camera lens. Image quality changes with a resulting loss of image sharpness, especially in the corners of the image and when the lenses are used at large apertures. The degree of quality loss depends mainly on the power of the close-up lens. With a low-power close-up lens of two meters (0.5 diopters),

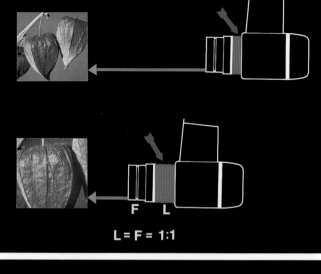

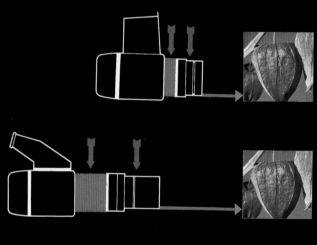

Above: Extension tubes and bellows allow the lens to move further from the image plane, which is necessary for close-up photography. *Top, Right:* A longer extension tube or bellows extension (L) allows you to get closer to the subject with the same focal length lens (F) (bottom). 1:1 magnification is achieved if the length of the tube or bellows is equal to the focal length of the lens. *Bottom, Right:* You can cover the same area with a shorter focal length lens and shorter tube or bellows extension (top) or a longer focal length lens and a longer tube or bellows (bottom) from a longer distance.

the loss of sharpness is seldom objectionable (mainly since smaller apertures are used in close-up work to increase depth of field). With a more powerful close-up lens of one diopter (one meter), sharpness can be acceptable with the lens aperture closed down. A more powerful lens of two or more diopters should not be considered for any serious close-up work.

For higher magnification, or for all close-up work where image quality is important, or where larger apertures must be used, consider using extension tubes or bellows (if the lenses on the camera are interchangeable).

Extension Tubes and Bellows. Extension tubes and bellows are phys-ically different but serve the same purpose in close-up photography. Both accessories are mounted between the camera and the lens for the purpose of moving the lens further away from the image plane. They just increase the lens-to-film distance without adding any optical components. For rigidity reasons, bellows should not be considered for use with heavy lenses.

Here are a few basic facts worth learning:

1. The longer the tube or bellows extension with a particular focal length lens, the closer the distance at which you can photograph, and consequently, the smaller the area coverage and the higher the magnification.

2. The same extension tube or extension on the bellows gives a different magnification and area coverage with different focal length lenses. You can cover a larger area with a shorter lens or a smaller area with a longer lens.

3. You can cover the same area with a shorter focal length lens and a shorter tube or bellows extension, or with a lens of longer focal length combined with a longer tube or extension on the bellows. The two differ in the working distance, the distance between the lens and the subject.

You can determine the necessary length of an extension tube or bellows extension with the following formula:

Length of extension = focal length of lens x magnification

For example, the extension necessary to obtain 0.5x magnification with an 80mm lens is 80 x 0.5 = 40mm; and with a 120mm lens, 120 x 0.5 = 60mm. Learning this relationship is invaluable—it eliminates time-consuming experimenting, moving cameras, and adding and changing lenses and accessories. The preceding formula (and some of the others to follow) are not scientifically accurate as they depend somewhat on the design of the lens. They are, however, sufficiently accurate for photographic purposes.

Choice of Lens. Basically all fixed focal length lenses can be used for close-up photography with extension tubes or bellows. For utmost image sharpness, it is best to consider lenses that are designed to produce good quality at close distances, or are designed specifically for that purpose. The Zeiss Makro-Planars or Rodenstock APO-Macro-Sironar are such types.

Retrofocus type wide-angle lenses without floating lens elements are not the best choice as they are designed for long-distance photography. They are usable for close-up photography, but only with the aperture closed down. The floating element designs are better choices.

Extension tubes, at least the shorter types, can be used with some zoom lenses, but not with others, so check the data sheets or consult the manufacturer. Even if short types are

Superb sharpness is possible with tubes or bellows, especially in combination with lenses designed for producing good image quality at close distances (Carl Zeiss Makro-Planar 135mm with bellows).

usable, you will probably find that the image does not stay in focus when zooming. You must refocus when setting the lens to a different focal length.

Exposure with Extension Tubes and Bellows. Extension tubes and bellows increase the lens to image plane distance, spreading the light over a larger area. Exposure therefore needs to be increased. A camera with a TTL built-in metering system measures the light through the lens and the close-up accessory, and therefore gives the correct reading without a manual adjust-

ment. If the reading is made with a separate meter, exposure must be increased based on the length of the tube or bellows extension in relation to the focal length of the lens. Charts are usually supplied with these accessories, but the correct lens aperture can also be determined from the formula on the following page.

Depth of Field in Close-up Photography. Depth of field at any distance and with any lens is determined only by the lens aperture and the area coverage (magnification). The depth of field can be increased only by clos-

ing the lens aperture or covering a larger area. Since this is so, the amount of depth of field can be indicated based on the magnification and applies to any camera and any image format.

● Exposure Calculation When Using Extension Tubes or Bellows with a Separate Meter

$$\text{LENS APERTURE} = \frac{\text{APERTURE ON METER X FOCAL LENGTH}}{\text{FOCAL LENGTH} + \text{LENGTH OF EXTENSION}}$$

Example for f/11, 80mm focal length, 30mm tube:

$$\frac{11 \times 80}{80 + 30} = \frac{880}{110} = F/8$$

● Total Depth of Field at F/11 (In Millimeters)

MAGNIFICATION	A	B
0.1x	145	73
0.2x	40	20
0.3x	19	10
0.5x	8	4
0.8x	4	2
1x	2.6	1.3
1.2x	2	1
1.5x	1.5	0.7
2x	1	0.5

(Column A is to be considered for general close-up work. Column B is for critical work.)

5

SELECTING AND
USING LENSES

●●

● Lenses for Area Coverage
The area coverage we hope to achieve dictates the focal length we must choose in each application. Wide-angle lenses, or zoom lenses set to a wide-angle position, cover a larger area and record subjects smaller than standard lenses.

Telephoto lenses (or zoom lenses set to a longer focal length) cover less

than the standard lens when used from the same camera position. This means that they record subjects larger. Area coverage and subject size are directly related to the focal length. A lens that has twice the focal length covers an area half as wide and high on the same film format. As a result, the subject is rendered twice as large in the frame.

● Effective Wide-Angle Photography
Consider wide-angle lenses not only for the purpose of covering larger areas but also for enhancing the three-dimensional aspect of a scene. They work beautifully for this purpose. All you need to do is include effective foreground elements in the composition. The wide-angle lens, with its

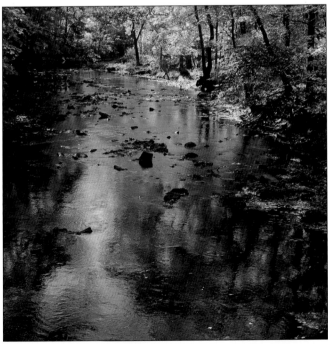 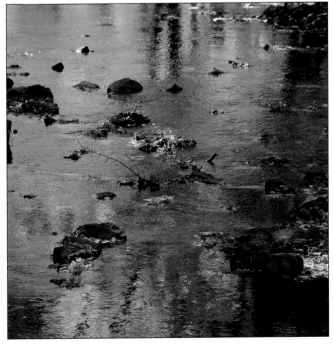

After taking the overall shot (left) look for possibilities for closer views (right). Use a longer lens if you cannot approach the subject.

SELECTING AND USING LENSES 95

Wide-angle lenses enhance the feeling for depth and distance. In this case, the slanted lines of the railroad tracks produce the effect.

A foreground was included in this wide-angle picture to enhance the depth in the landscape.

large coverage and depth of field, makes this easy. The foreground subjects can be anything—a rock or rock formation, a flower bed, an area of water, a field, a tree stump, a fence, you name it. Such compositions can be especially effective when the foreground area includes lines that lead the eye toward the distant background and thereby adds depth and a three-dimensional feeling to the image. This approach is especially effective with wide-angle lenses because the shorter focal length emphasizes the size relationship between foreground and background, making the background

subjects appear to be further away than they actually are.

Subject Distortions with Wide-Angle Lenses. When photographing with short wide-angle lenses or photographing in the panoramic format, it is

tographed from a different angle than those in the center. The effect can become somewhat disturbing, especially when the entire composition includes similar or identical subjects as might be the case when photograph-

This approach is especially effective with wide-angle lenses. . .

wise to evaluate the composition carefully in the viewfinder or on the focusing screen—at least when time permits you to do so. Due to the wide area coverage, three-dimensional subjects on the sides are seen and pho-

ing arrangements of fruit or vegetables or flowerpots in a marketplace. The pots in front of the lens are photographed from the front, those to the left and right from the side. It is not really a distorted view as we see the

Top: With extreme wide-angle lenses and in panoramic cameras, slanted lines created from tilting the camera are enhanced. Leveling the camera may have to be considered more carefully with some subjects. **Bottom:** *In pictures taken with extreme wide-angle lenses or with panoramic cameras, the subjects on the sides are seen from a somewhat different angle than those in the center.*

subjects the same way with our eyes. With our eyes, however, we do not look at all the pots from left to right at the same time. We turn the head, or at least the eyes to see those on the sides. In a photographic image we look at all of them simultaneously and the distortion may disturb us.

With wide-angle lenses, the slightest tilt of the camera produces slanted lines. To maintain parallel verticals, the camera must be precisely leveled. Consider using a spirit level to gauge your camera position. These are sold separately as accessories, but are sometimes built into the camera, viewfinder, or tripod coupling.

● **Fisheye Photography**

Full-frame fisheye lenses record subjects differently than we see them with our eyes. This is usually the first and main reason for considering the fisheye approach with its beautifully curved lines. If used for that purpose, try to effectively emphasize the curved lines. Use the lens where the curved lines add visual impact, where the images convey the feeling that the fisheye lens was used for a good reason—not just to be different. Select subjects where the fisheye look may create the proper mood—in an amuse-

*Top, Left: A quality full-frame fisheye image must have good sharpness and illumination all the way into the corners of the image (30mm Carl Zeiss Distagon). **Top, Right:** Full-frame fisheye images are most effective with equally curved lines on both sides of the image. **Right:** In a full-frame fisheye image, diagonal lines composed to go through the center of the image, like this tree, are perfectly straight.*

ment park, perhaps, or for a portrait of a clown.

Fisheye images must be carefully composed. Such images are usually effective when equally curved lines appear on both sides of the image (or on top and bottom). Whether photographing a building from the outside or inside, compose so the center of the structure is also in the center of the image with the curved lines almost equally balanced on both sides, or on top and bottom. A fisheye image of a group of trees is most effective when the trees on the left and right side are somewhat balanced and have the same amount of curvature. If all or most of the curved lines are on one side, the image may look lopsided. A single subject should be perfectly centered.

Non-Fisheye Images. With a full-frame fisheye lens, a horizontal, vertical, or diagonal line going exactly through the center of the frame always appears perfectly straight in the image. The horizon line in a landscape placed in the center of the image appears perfectly straight. Subjects to the left and right, top and bottom will have curved lines, but if the subjects are not dominant, the curvature may be hardly recognizable. A round subject, composed in the center of the frame, is recorded as a perfectly round shape.

Such images differ from wide-angle pictures mainly in their diagonal 180° area coverage. Producing images with this "non-fisheye" look is often the best reason to use such lenses.

● **Background Area Coverage**
Different focal length lenses, or focal length settings on a zoom lens, allow us to include smaller or larger background areas in our images. For example, we can take a full-length picture of a bride and groom with a standard lens, use a wide-angle from a closer

Backgrounds are a major and important part of many images . . .

distance, or a telephoto from a longer distance. While this approach records the bride and groom in the same size, the total image is not the same. Taken at a shorter focal length, the image includes a large background area—perhaps a good part of the church or other room interior. Taken at a longer focal length, the background area is reduced, including only the area directly behind the bride and groom—perhaps just one of the stained glass windows.

Backgrounds are a major and important part of many images taken outdoors or indoors, and how much

*Left: A shorter focal length lens was used here to include a large portion of the marketplace in the background. **Right:** Short telephoto lenses are a good choice for location portraits; they blur the background sufficiently when used at larger apertures.*

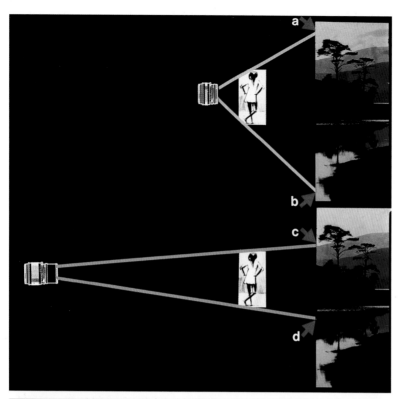

When using a short focal length lens, a large background area (from a to b) is included. The background area coverage is reduced (c to d) at a longer focal length, while the size of the foreground subject is maintained.

A 120mm lens on a medium format camera, equal to 80mm on 35mm, used in a studio setting.

we include may determine the effectiveness of the picture. Background coverage is a major compositional consideration and should be an important factor in selecting a specific focal length for a picture. Larger background coverage makes the background a more dominant part of the picture; it also helps to establish a location—to show where the picture was taken. Coverage with longer focal lengths creates a smaller background area. These longer focal lengths can eliminate objectionable or distracting subjects in the background, with little or no deviation from the original angle.

Different Focal Length Lenses in the Studio. Everything I've said (and will say) about lenses applies to their use in the studio as well. In the studio, longer focal length lenses provide the option of working with smaller backdrops. A lens double the focal length of the standard type requires a backdrop that is only half as wide and

high. This is especially beneficial when photographing large products or full-length portrait or fashion shots.

● **Background Subject Size**
The focal length of a lens not only determines the background area coverage, but also determines the size of the background elements. Whatever is in the background of a main subject appears twice as large with a lens that has double the focal length of the

standard type. We can keep the size of the main subject in the foreground—a person, for example—constant by photographing him/her with the longer lens from a longer distance, twenty feet perhaps, or with a shorter lens from a shorter distance of perhaps five feet.

In this approach we actually changed the size relationship between

foreground and background (the subject size remained constant while the background size changed). This means that we have changed the perspective. Perspective is the size relationship between foreground and background. With longer focal length lenses, background subjects appear larger and therefore closer to the camera. Shorter lenses record background elements smaller than standard lenses—they appear to be further away.

The ability to change our perspective offers wonderful opportunities. . .

The ability to change our perspective offers wonderful opportunities to create images that are different from the way we normally see the world. With our eyes, we see everything in normal perspective, the way an image is recorded by a standard lens. While a standard lens must be used if the subject or scene is to be recorded as we normally see it, in using shorter or

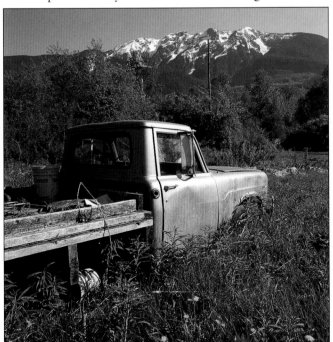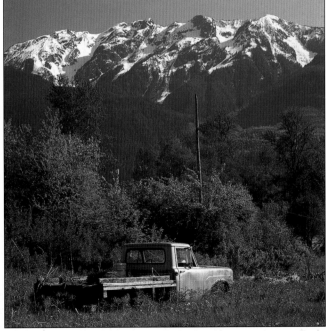

The size relationship between the truck in the foreground and the mountains in the background is completely different when taken with a telephoto lens (right) and a wide-angle lens (left).

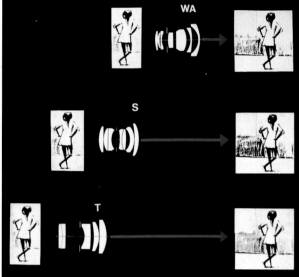

*Left: A standard lens records the scene as seen with our eyes, allows handheld photography, and blurs background sufficiently when used at large apertures. **Above:** Different focal length lenses (wide-angle [WA], standard [S], and telephoto [T]) can be used from different distances to cover the same foreground subject. The images differ in perspective, background coverage, and background sharpness.*

longer focal lengths we can compress or enhance perspective.

When shooting outdoors, longer focal length lenses create wonderful opportunities to make background

by the focal length of the lens. Not so. If different focal length lenses are used from the same distance, the foreground/background size relationship—the perspective—is the same.

when far away, will hardly change in size. You have changed the size relationship, but this approach with the same focal length lens does not produce a visually dramatic change in perspective. The difference is mainly in the size of the foreground subject. For more dramatic results, you need to change the the size of the background subjects and, for this purpose, you will need different focal length lenses. Longer focal length lenses enlarge the background subjects and make them appear closer; shorter lenses do the opposite. Using different focal lengths, you can cover a foreground subject identically from shorter or longer distances.

Perspective is determined by the distance between the camera and foreground subject.

areas more dominant. A mountain range that may be hardly recognizable in the distance with our eyes or when photographed with a standard focal length lens becomes larger and more majestic—perhaps filling the entire frame—with a telephoto.

● Other Facts
About Perspective

I hope that the discussion of perspective has not given the impression that perspective in a picture is determined

The different lenses record both the foreground and background subjects equally larger or smaller without changing the size relationship between them.

Perspective is determined by the distance between the camera and foreground subject. You can therefore change perspective with one and the same lens by photographing the foreground subject from different distances so it appears larger or smaller in the image. The background, especially

While you do not need different focal length lenses to create different perspectives, they are extremely helpful and provide much greater possibil-

ities as they allow you to change perspective while maintaining the foreground subject size. Using different focal lengths, you can cover a foreground subject identically from shorter or longer distances.

To complete the discussion of perspective, I must mention that the perspective we see in a print or a projected transparency or movie scene is determined by the viewing distance. An image taken at any focal length appears in normal perspective when viewed from a distance (D) that is equal to the focal length of the lens (F) multiplied by the degree of enlargement (M) of the print, slide, or movie scene. $D = F \times M$. Since we normally view all images of a specific size from the same distance, this discussion is, however, more theoretical.

● Lenses for
Location Portraiture
The wide choice of locations, props, backgrounds and lighting offers unique opportunities when photographing people on location and is a main reason why so much portrait and fashion work is done outside the studio. Consider these elements a main reason for working on location and use them effectively. Don't try to duplicate the approach that you might use in the studio—make your location shots as unique as possible.

An easy way to accomplish this goal is by making the setting (the background) an important part of the image. Select a location that enhances the image, is appropriate for the feeling you'd like to create, and suits the clothing the subjects are wearing. Country locations, fields, forests, and old barns are fine for casual wear. For formal wear, you may want to consider a town setting, beautiful or interesting architecture, or stairways, but the pattern on an old barn can also be very effective. Trees often come to mind first for an outdoor background. I consider them a boring, unattractive backdrop for a portrait, except when the trees display brilliant fall colors.

Color must also be considered—it must enhance the image rather than

The size of the background area must be carefully considered.

detract from it. A colorful background is great when the subject of the photograph is wearing white, gray or black. When the subjects are wearing colorful clothing, using subdued colors in the background will likely be more appropriate.

The size of the background area to be included in the picture must be carefully evaluated. Include a small area for a subdued background, but use a large area when you want to establish the location in the image. Be sure to use a camera position and focal

Left: *The telephone and newspaper boxes worked well with the casual outfit on this model and added color to the picture.* *Right:* *A formal-looking background was selected for this more formal outfit.*

A composition in the square format (left) instead of the vertical usually used for people pictures (right) allows the background to be made a more dominant part of the portrait without reducing the size of the model.

Left: *The adobe colors in Albuquerque combined beautifully with the blue outfit on this model.* ***Right:*** *A standard focal length lens is a good choice for full-length pictures, allowing the photographer to be close to the subject for good communication. This colorful location was chosen because the red formed an excellent background for the blue outfit. This photograph was taken in about 1973.*

length that produces the desired results. Including a large background area enhances the feel of an outdoor shoot; thus, wide-angle lenses and fisheye lenses are popular choices in outdoor portrait photography.

A background can also be made more dominant in an outdoor portrait by composing the subject and the background in the square format. The additional space on the sides allows you to include more of the background area without making the person, or persons, smaller. This approach works especially well in ¾-length and full-length pictures of individuals or groups taken with any focal length lens.

Everything that has been said applies also to location portraits made indoors. Wide-angle, or even fisheye lenses can be especially helpful by including a large portion of an industrial interior, a restaurant, a museum. A beautiful church interior can lend a special mood to a wedding portrait.

Composing Group Pictures. There seems to be a difference of opinion as to whether the people in a group picture must be arranged on a straight or curved line in order to have everybody from left to right sharp in the picture.

The people must be on a stright line for maximum sharpness. . .

This question comes up especially when wide-angle lenses are used. Arranged in a straight line, the people on the outside are further from the lens (perhaps 15') than those in the center (perhaps 10') when measured from the lens. For this reason, some photographers feel that it is necessary to arrange the group on a curved line so everyone is at the same distance from the lens.

This argument is incorrect. Every camera lens is designed to produce a sharp image on the flat image plane from a flat subject in front of the lens, for example, from the wall of a building or a copyboard. This also applies to group pictures. The people must be on a straight line for maximum sharpness. If you prefer to arrange the peo-

ple in a curved line because it looks better or because you'll be using a flash, feel free to do so, but realize that the people on the sides are now closer

to the image plane (about 7', for example) than those in the center (perhaps 10'). The lens aperture must be closed down to meet the requirement for greater depth of field.

● **Background Sharpness.**
The focal length should often be selected based on the desired degree of sharpness or unsharpness in the background. While the actual depth of field is identical with any lens at the same aperture when covering the same area, backgrounds are more blurred, less recognizable, less distracting, or can be completely blurred with a longer focal length lens. No matter what lens you select, the lens aperture can and should always be used as an additional tool for controlling back-

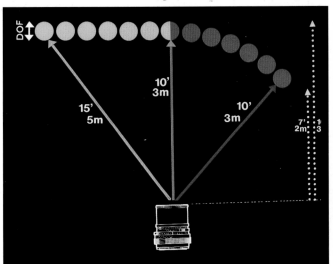 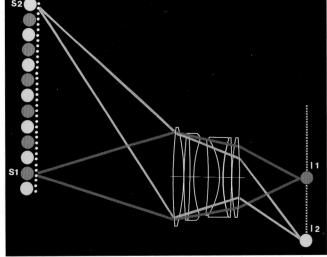

For maximum sharpness, the people in a group must be aligned on a straight line as shown on the left (yellow dots). As shown in the diagram on the right, this alignment is necessary as all lenses are designed to form on the image plane (I₁, I₂) an image from a flat, not a curved, subject (S₁, S₂). Aligned in a curve, as on the right portion of the left illustration (red dots), the people on the sides are closer to the image plane and the lens must be stopped down for the required depth of field.

At the same lens aperture, the longer focal length lens (left) creates much more blur in the enlarged background than a shorter focal length (right).

120–150mm (or 75–90mm on a 35mm camera) is a good focal length for both candid and formal people pictures in the 6cm x 6cm format.

Left: A completely blurred foreground added a touch of color to this otherwise monocolor scene in Austria. 250mm lens on medium format camera (about 150mm on 35mm). Right: Sharp outlines, such as the features of architectural structures, usually look best when they appear sharp from foreground to background.

ground sharpness. A shorter focal length keeps backgrounds sharper and more recognizable at the same lens aperture.

● Foreground Sharpness

Everything that has been said about background sharpness also applies to subjects that are closer to the camera than the depth of field range. You can frequently produce effective images—especially outdoors—by planning the composition around some completely blurred foreground objects such as flowers, leaves, or grasses. They can enhance the feeling for depth, add a touch of color, or simply make the image look more artistic.

Blurred foreground subjects must be carefully chosen to ascertain that they add visual impact to the image rather than being a distraction. Subjects with straight lines, such as furniture and fences, usually look better when they are sharp. The best fore-

ground subjects are objects with nice curved outlines, such as a blurred patch of flowers.

Out of focus foregrounds look best when blurred beyond recognition. When blurred just a little, the effect might look like a mistake. If the standard lens does not provide enough blur, go to a longer lens. Blurred foregrounds seldom work in black and white photography.

● Evaluating Image Sharpness and Depth of Field in the Camera

Being able to see the depth of field is often mentioned as the main benefit of the SLR viewing system. Since depth of field is the range of acceptable sharpness based on a certain degree of enlargement, the above statement must be analyzed more carefully.

In the camera's viewing system, you see a small image on a small focusing screen (24mm x 36mm in 35mm,

55mm x 55mm on a square medium format camera). While you can determine what is critically sharp and what is blurred on this small image, you cannot gauge where sharpness will be acceptable or unacceptable in the final image. Stopping down the lens aperture in order to see the image at the set diaphragm opening makes the situation still worse as it reduces the image brightness. Consequently, you shouldn't try to determine depth of field on the focusing screen. Consult the depth of field scales instead.

Using the SLR Viewfinder. While not usable for determining depth of field, focusing screens in SLR cameras beautifully show the amount of sharpness or unsharpness in background and foreground areas and how the degree of sharpness changes as the lens aperture is opened or closed. The SLR finder is an excellent tool in evaluating the effectiveness of the image and should be used for that purpose in

combination with the manual aperture stop-down control.

On SLR cameras, the lens aperture is always fully open to provide the brightest image on the focusing screen. The image you normally see, therefore, reflects the wide-open aperture setting. With the manual stop-down control you can see what the image looks like at any aperture setting and can determine which aperture will provide the desired result. A manual stop-down control must be part of every lens or camera used for serious photography.

A medium or large format camera, with its larger focusing screen, has an advantage over 35mm, perhaps providing better and more effective image evaluation with the aperture wide open or closed down. With a square format camera, you have the additional benefit of viewing the image on the screen from different angles with different finders. Using a standard focusing hood, you can even evaluate the image with both eyes open as you evaluate the image on a large format camera.

● Use and Application of Tilt Control

On an "ordinary" camera, the sharpness range is determined by the area coverage and lens aperture. When covering a specific size area with a specific lens, or a zoom lens set at a specific focal length, the sharpness range is determined only by the lens aperture.

When we photograph a flat plane from an oblique angle—as may be the case in a tabletop setting, in a food illustration or in many landscape photographs such as a flower bed or a meadow—the sharpness range can be

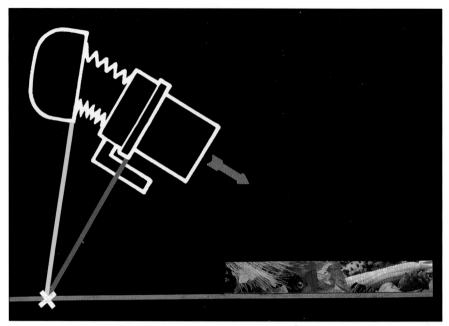

The maximum sharpness range is obtained when lines extended from the lens plane and the image plane meet at a common point on a line extended from the subject plane.

further controlled by tilting the film plane or the lens plane in relation to the other. Photographers using large format cameras have known for years that in using this control, the maximum range of sharpness is achieved when a line extended from the image plane and a line extended from the lens plane meet at a common point on

a line extended from the subject plane. You can have practically unlimited sharpness from front to back while working at large lens apertures and, consequently, at short shutter speeds.

On large format cameras, you can tilt either the film plane or the lens plane or both. On specially designed medium format cameras, the tilting is done with the image plane. For some 35mm cameras, special lenses with a tilt control are available.

No matter which plane is tilted, you can align the camera by drawing

imaginary lines downward from the front frame and the rear frame and tilt either or both until the lines meet at a common point on a plane extended from the subject plane.

It is usually easier, faster, and more practical to make the needed adjustments by visually evaluating the image on the focusing screen. Start by

On large format cameras, you can tilt either the film plane or the lens plane or both.

focusing the lens on a point about ⅓ from the nearest point, ⅔ from the farthest part of the subject that is to appear sharp in the photograph. Tilt the image or lens plane in one direction and check whether the sharpness range increases. If not, tilt the plane in the other direction. Check the sharpness at the top and bottom and see whether both become critically sharp. If not, change the focus setting on the lens. You will quickly find a point where you have sharpness over the entire plane.

I must emphasize that the sharpness control by tilting the lens or image plane is completely independent from the sharpness control with depth of field. Depth of field is controlled only by the lens and lens aperture. Tilting the image plane controls the range of sharpness, not the depth of field. You can often accomplish the desired results by simply tilting the image or lens plane, but many times you need to work in combination with the lens aperture.

Limitation in Sharpness Controls. Sharpness over the entire image area by tilting the image or lens plane can be achieved only when photographing a subject on a flat plane, as might be the case with documents, pictures laying on a flat table surface, or a flat landscape without trees, for example. In such cases you can accomplish excellent sharpness over the entire area, even with the lens aperture wide open. If there are any three-dimensional subjects on the table, a cup and saucer, a vase with flowers, a loaf of bread, a bottle of wine, or a building or tree in a landscape, the various subjects are no longer on a flat plane. We

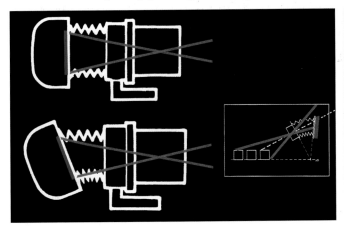

Above: The covering power of a lens need not be increased when the image plane is tilted around its center (left). When tilting the lens plane (right), the lens needs to cover a larger area. *Right:* "Regular" lenses made for the camera's image format without additional covering power produce excellent sharpness and illumination into the corners if the image plane is tilted around its axis. (120mm Carl Zeiss Makro-Planar on Flexbody)

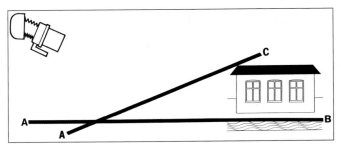

Above: Tilting the image or lens plane results in sharpness along one axis only (A to B). If a subject, a tree or building, extends above this image plane, you could tilt for the image plane A to C, but this keeps the plane at B out of focus. It is usually better to tilt for A to B and close the lens aperture to maintain sharpness in the subjects that protrude above the A–B plane. *Right:* The tops of all of these pumpkins are sharp because they are in the same plane. The front of the pumpkin closest to the camera is unsharp as it is on a different plane. Closing down the aperture to increase depth of field would have resulted in overall sharpness.

Straight and parallel verticals were achieved in this picture of the Smolniy Convent in St. Petersburg, Russia with shift control in the lens plane. (50mm Carl Zeiss Distagon in combination with Carl Zeiss PC Mutar shift converter.)

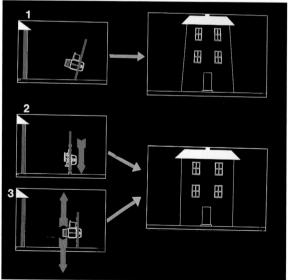

Instead of tilting the camera, which produces slanted verticals (1), you can shift either the image plane (2) or the lens plane (3), keeping the image plane parallel to the subject in either case.

have at least two different image planes—one is the table surface, or the flat landscape, the other going from the front of the table or landscape over the top of the various objects, the wine bottle, the flowers, the building or tree. You can adjust the tilt for either one of these image planes but not for both. The difference must be corrected with the lens aperture and its resulting depth of field.

You could try to adjust the tilt in between the two planes, but it is usually easier to do it visually for one or the other.

Covering Power with Tilt Control. The covering power of the lens need not be greater than necessary in order to cover the image format if the tilting is done around the center of the image plane. That explains why the lenses designed to cover the 2¼" (6cm x 6cm) format can also be used on the Hasselblad Flexbody. When tilting the lens plane, you must have lenses with a covering power larger than the image format.

On 35mm and medium format cameras, the tilt control is likely in one direction—vertical only. You must turn the camera for tilt control in the other direction.

Using Tilt Control for Creative Purposes. Tilt control can also be used to limit the sharpness range. In a commercial illustration, you can limit the sharpness to one specific product; in a portrait, limit the sharpness to the person—or even part of the person—with the rest of the image area blurred. Creating the blur by tilting the image or lens plane is especially helpful when the areas next to the subject are at the same distance, in which case the depth of field control does not work.

Be careful, however, when using this technique. It is a special effect that can easily look artificial and attract unnecessary attention. Like any other special effect, you must be careful not to overdo it to the point where it attracts attention.

● Applying Shift Control

Shift control is mainly used in architectural work and in product photography. Instead of tilting the camera upward or downward, which results in slanted verticals, you can shift the image plane or the lens plane and cover the same area while keeping the image plane parallel to the subject. As long as the image plane is parallel to the subject, the verticals will be straight and parallel in the picture. This is the secret to using the shift control.

On large format cameras, you can shift the front or the back or both. You can also shift both planes either vertically or horizontally. In 35mm, the shift is accomplished with PC lenses. In the medium format field, the possi-

On large format cameras, you can shift the front or the back or both.

bilities exist either with PC lenses or PC teleconverters or with special camera bodies that feature built-in shift control. You may have to turn the

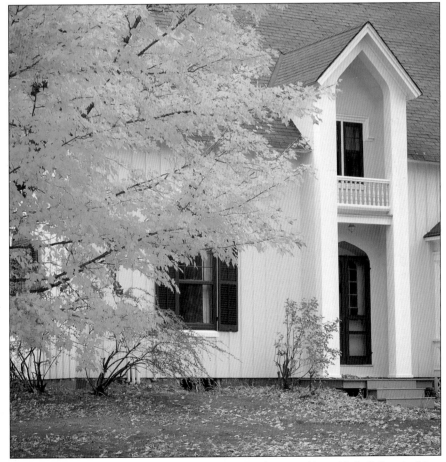

Straight and parallel verticals were achieved by photographing this building in New England with a longer lens from across the street.

camera for shift control in the horizontal plane—to photograph paintings on a wall from a slanted angle, for example.

Start by aligning the camera so the image plane is parallel to the subject, perhaps using a spirit level if available. Then move the shift control until the desired image area is covered. Decide on the lens aperture as you usually do. Shifting does not change the focusing approach and does not require a small aperture for increased depth of field.

Large format camera lenses should, as is usually the case, be used at the recommended apertures that produce maximum image sharpness.

Limitations of Shift Control. The covering power of the lens is the limiting factor for the shift capability on any camera. The lens cannot be shifted beyond its covering power. If you do, the corners are vignetted, darkened, or simply do not have satisfactory image sharpness. Large format and PC lenses or PC converters are optically

designed to allow a certain amount of shifting. Be sure to read the specification sheets.

● Purpose and Use of Fresnel Correction Slides

Whenever a lens or image plane is shifted or tilted, the light rays entering the lens are no longer in line with the viewing axis. As a result, the top or bottom of the image appears darkened on the focusing screen, making image evaluation and sharpness control more difficult. This darkening happens only on the focusing screen, not on the image.

Fresnel focusing slides are available for medium format camera systems. They are inserted between the focusing screen and the viewfinder and provide even brightness over the focusing screen area no matter how much one of the planes is shifted or tilted.

● Correcting Verticals in Other Ways

Slanted lines can sometimes be avoided, or at least reduced, by photographing from a longer distance with a longer focal length lens. The longer distance may eliminate or at least reduce the need for tilting the camera. This approach only works when there is room to move away from the building, which is often not the case, and when there are no ugly telephone and power lines in front of the building.

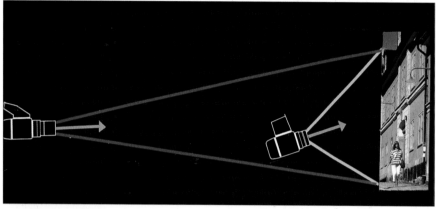

A longer shooting distance with a longer focal length lens reduces or eliminates the need to tilt the camera.

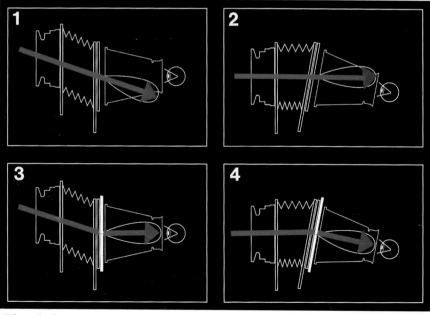

When the lens or image plane is shifted (1) or tilted (2), the eye is no longer in the optical axis resulting in dark areas on the focusing screen. A Fresnel plate (3 and 4) can divert the light to the eye for even brightness over the entire screen area.

GLOSSARY

Acutance—Lens and photographic technicians have found that the degree of sharpness we perceive is not only determined by the resolution of fine detail (the amount of detail we see), but more by the edge sharpness of the lines within the image. This is known as acutance. Acutance values correlate directly with the viewer's perception of the sharpness of an image.

Advanced photo system (APS)—A relatively new film format, smaller than 35mm, that offers advantages mainly in film loading, printing and storing of images. The images can be recorded in three different formats: standard, wide and panoramic. The smaller format also allows for the production of more compact cameras.

Angle of view—The angle of the area the lens covers when it is used on a specific film format. The angle of view can be related either to the diagonal, horizontal, or vertical dimension of the picture format, and can be indicated in either way on lens and camera specification sheets.

Aperture—The size of the opening of the lens diaphragm. The maximum aperture of a lens is obtained by dividing the focal length of the lens into its entrance pupil (known to the lens designer).

Apochromatic lens—When designing photographic lenses, the designer is mainly concerned about correcting the chromatic (color) aberration for two colors, usually red and blue. Such a design can result in a high quality lens without noticeable color fringes in all but the longest focal lengths. Such lenses are known as achromatic. Eliminating color fringes completely, for producing the best edge sharpness in long focal length lenses, may require a lens that is corrected for three colors, usually red, blue and green. Such a lens is apochromatic.

Area coverage—The angle of view of a lens determines the area coverage and the magnification. The area coverage for any lens is directly proportional to the subject's distance from the lens. At twice the distance, a lens covers an area twice as wide; at half the distance, the lens covers an area half as wide. A lens with a larger angle of view covers a larger area from the same distance, which also means that the magnification is lower and the subject is recorded smaller.

Aspheric lens—Lens element with one or two aspheric surfaces. Such elements are used in some photographic lenses. Since aspheric lens elements are difficult to manufacture, lens designers will not employ them unless absolutely essential. They try to obtain the required lens quality with the use of spheric lens elements.

Astigmatism—A lens has astigmatism if it forms the image of vertical and horizontal lines in the subject at different image planes, thus requiring different focus settings on the lens. This is naturally unacceptable in a high quality lens. Astigmatism is also a common fault in human eyesight, but one that does not usually affect viewing through a camera finder.

Average brightness—A subject that reflects 18% of the light is considered average brightness (gray card). Reflected light meters are adjusted to provide the correct lens settings for a subject of average brightness.

Barreli distortion—Lens distortion in which straight lines at the edge of the frame appear to bend inward.

Bellows—A flexible connection between the camera and lens. It is usually an accessory for 35mm and medium format cameras where it allows moving the lens further from the image plane for close-up photography. A bellows is also a part of most large cameras and some medium format types where it is used for focusing or for shift and tilt control.

Blurred motion—An unsharpness in the image that is caused by either the subject or the camera moving while the shutter is open. While unacceptable in most images where the highest quality is required, the blur can also be used effectively to convey the feeling of motion, (sports or water, for example). The slower the shutter speed the more enhanced the effect.

Cable release—An accessory attached to the camera to release the shutter without touching the release button. Recommended when working at longer shutter speeds to reduce the danger of camera movement. Some cable releases have a lock, helpful for very long exposures. A cable release is not needed for handheld photography.

CCD—(Charge Coupled Device) Device used to record digital images in digital cameras. The size of the CCD in professional cameras and digital backs for medium and large format cameras also varies, but is often about the size of a 35mm frame or slightly larger.

Center Gray Filter—A gradual neutral density filter that absorbs more light in the center for the purpose of achieving more even illumination over the entire image area with extreme wide-angle lenses or lenses used on panoramic cameras.

Chromatic aberration—Like a prism, a lens element disperses white light into the different colors of the spectrum. The different colored rays form their images at different distances from the lens and, consequently, also produce images of different sizes. If this is not corrected for in the lens design, the resulting condition is called chromatic aberration.Chromatic aberration affects the image quality across the entire image area.

Close-up lens—Close-up lenses are positive lens elements that are mounted in front of the camera lens like a filter. They are used when the camera lens does not focus close enough to cover a small area.

Close-up photography—Refers to photographing small subjects from close distances. There is no standard setting dividing the line between close-up and long distance photography. The dividing line is frequently based on the minimum focusing distance of the lens and where the need for the use of close-up accessories starts. With macro lenses, a good range of close-up pho-tography can be done without the need for accessories.

CMOS—(Complementary Metal-Oxide Semiconductor) Device used to record digital images in digital cameras. The CMOS in professional cameras and digital backs for medium and large format cameras also varies, but is often about the size of a 35mm frame or slightly larger.

Coma—Coma occurs with light rays entering the lens at an angle and, therefore, appearing mainly (or only) on the outside areas of the image. The point source appears as an image of a point with an asymmetrical tail attached at one end and resembles a moving comet.

Composition—Making an effective, pleasing arrangement of lines, shapes and colors within the frame.

Covering power—Lenses are optically designed to produce satisfactory image quality and illumination for a specific image format. With 35mm lenses, this quality is delivered when used on the 24mm x 36mm format. Medium format lenses on a 6cm x 6cm function the same way on the 2¼" inch (6cm x 6cm) square format, but not necessarily on anything larger. This lens design characteristic is called covering power. The covering power depends on the design of the lens, not the focal length.

Dedicated flash—A camera/flash system where the flash unit is electronically dedicated to the camera, measuring the flash through the camera lens. A sensor in the camera measures the flash (usually reflected off

the film plane) and turns the flash off when the proper amount for correct exposure is reached.

Depth of field—The range of sharpness in front of and behind the focused distance that is considered acceptably sharp in the final image. Depth of field is increased by closing the lens aperture. Depth of field is a calculated figure and not dependent on the lens design.

Depth of focus—The distance range at the image plane that produces acceptable sharpness with a specific lens at a specific aperture.

Diaphragm—A device built into the lens allows for a reduction of the aperture from the maximum lens aperture to f/16, f/22, f/32 or even smaller. This operation may be automatic or manual. Lens diaphragm design varies, with some having more diaphragm blades than others. There is no difference in the operation or the exposure accuracy. (In images where a bright light source shines into the lens, the image of the diaphragm may become visible on the film. Some photographers feel that the almost-round shape of a diaphragm with more blades is nicer than one in which you can see the separate blades.)

Digital camera—A camera where the image is recorded and stored electronically, not on film. Some medium format cameras can be used for digital recording by attaching a digital back instead of a roll film magazine.

Diopter—Term used to indicate the focal length of a lens, especially in eyeglasses. One diopter is equal to a one meter focal length. In photography, diopter is used in connection with close-up lenses and in relation to correcting the camera viewfinder eyepiece to the photographer's eyesight.

Distortion—The inability of the lens to record straight lines as straight over the entire film area. *See also* Pincushion distortion and Barrell distortion.

Double exposure—When two or more images are recorded on the same piece of film, usually for creating a special effect.

Electronic flash—An excellent, bright source of light that can be used alone or in combination with daylight as both have the same color temperature. A large amount of light can be produced by a small and lightweight unit that can be mounted on the camera. Many cameras have a built-in flash.

Electronic imaging—Technology that allows images to be produced electronically, eliminating the need for film, film processing and the use of chemicals.

Electronic sensor—The light-sensitive microchip that records the image in a digital camera or digital back. Can be a CCD (charge-coupled device) or CMOS (complementary metal oxide semiconductor). Camera specifications indicate its size in the number of pixels it records, such as 2046 x 1536 (over three megapixels) or 3040 x 2016 (over six megapixels). A higher number of pixels is likely to produce higher image quality.

Enlarging lens—Lens used in the darkroom to create enlargements from negtives. The lens on an enlarger needs to have good quality to reproduce the sharpness from the negative on the enlarging paper, but does not need the controls that are necessary for use on the camera.

Exposure meter—A device that measures the light or the subject brightness and gives us the aperture and shutter speed figures. The meter can be built into the camera or can be a separate accessory.

Exposure values—A few lenses, mainly in the medium format, have an exposure value (EV) scale. Exposure values are single numbers that indicate how much light exists in a certain location based on the ISO that is set on the meter.

Field curvature—A single lens element produces its image on a curved plane. The lens designer must try to "straighten" the image plane, reducing its curvature to a point where the sharpness is acceptable over the entire image area. *See also* Flat field lens.

Fill light—Light used in addition to the main light to add illumination to dark or shaded areas. Electronic flash or reflectors are usually used for this purpose in location photography.

Film plane—The position of the film in the camera body or film magazine. Focusing distances are always measured from the film plane.

Film reflectance—The amount of light that is reflected off the film sur-

face. May have to be considered in a dedicated flash system where the sensor measures the light reflected off the film plane.

Film scanner—Device that allows you to scan (create digital images of) your negatives or transparencies so they can be stored or added to a website, as well as adjusted or enhanced in many ways.

Film sensitivity—Indicates how sensitive the film is to light, and determines the aperture and/or shutter speeds that are necessary to record a properly exposed image on the film. A film with a higher ISO number is more sensitive and therefore recommended in low light situations.

Filter factor—A figure indicating how much light a filter absorbs, thus requiring an increase in exposure when the filter is used. Filter factors are not, however, equivalent to *f*-stops.

Fisheye lens—Lens that is designed so the angle of view diagonally is much greater (usually 180°) in relation to the angle of view horizontally or vertically. They produce an image with curved lines outside the center area.

Fixed focus—A lens found in point & shoot cameras that cannot be adjusted for different subject distances. The focal length is usually short and the aperture relatively small so that the depth of field covers a satisfactory distance range with acceptable sharpness.

Flare—Images with a haze-like appearance, called flare, are unacceptable for most uses. Flare can appear with any lens on any camera if the sun or a bright light source shines directly on the lens surface or when photographing against bright white backgrounds. Flare may also show up with some lenses when the subject or scene includes very bright areas. Flare can be created by light reflections on lens surfaces, the interior of lens barrels, or camera bodies.

Flat field lens—Some lenses are referred to as "flat field" types, meaning that they are exceptionally well corrected for field curvature. This is a main requirement for copying and color separation work. Many other lenses that are not specifically called flat field also produce images of excellent flatness in general photography. The Planar types, for example, fall into this category. In some cases, the term "flat field" may be used in advertising claims as there are no standards to separate "regular" from "flat field" types.

Floating lens element—A wide-angle lens design where some of the lens elements can be moved. Used in retrofocus wide-angle designs to improve the image quality at close distances.

Fluorescence photography—This concerns photographing objects and materials that fluoresce when subjected to UV light. The radiation reflected from the subject has a longer wavelength than the UV light and, therefore, is visible to the human eye as the typical fluorescent colors.

Fluoride—An artificially crystallized form of calcium fluoride that is used instead of glass for some lens elements in apochromatic lenses.

Focal length—Distance from the principal plane in the lens (known to the lens designer) to the point at which the lens forms an image of a subject at infinity. The focal length is always engraved on the lens. The focal length of a lens is the same no matter where or how it is used—and regardless of what image format it is to cover. The specifications for digital cameras often do not state the actual focal length of the lens on the camera, but the equivalent focal length on a 35mm camera. This makes sense due to the different sizes of electronic sensors in different digital cameras and digital backs.

Focusing hood—A foldable viewfinder that is standard on most medium format cameras. It is usually interchangeable with a prism viewfinder.

Focusing range—The minimum and maximum distances at which sharp images can be produced with a specific lens without the use of any accessories.

Focusing screen—In single lens reflex and large format cameras, the image is viewed on a focusing screen rather than an optical viewfinder. On large format and special medium format cameras, the focusing screen is added to the camera in place of the film holder or magazine. On single lens reflex cameras, the mirror projects the image to the focusing screen before the image is made. Focusing screens come in many different versions, and also with added microprisms, split image rangefinders, checked lines, etc.

Foreshortening—Effect that occurs when the camera is too close to the subject. Results in parts of the subject

appearing too large in relation to the whole.

Fresnel Lens or plate—A plate, usually made from acrylic material, that is combined with a focusing screen to provide better corner brightness on the focusing screen of an SLR camera. Also used to provide even brightness on a focusing screen when shift and tilt control is used.

Full-frame fisheye lens—An image produced in a full-frame fisheye lens covers the entire image area. Other fisheye lenses just produce a circular image in the center of the image area. Full-frame fisheye types have much wider applications.

High resolution film—Film with high detail and fine grain that is capable of producing the utmost image sharpness. Films with lower sensitivities usually have these characteristics.

Hyperfocal distance—The distance setting on a lens that provides depth of field to infinity at a specific aperture.

Image circle—While the term "covering power" (*see* Covering power) is frequently used in working with smaller formats, the term "image circle" is used to describe the same qualities when working with lenses designed for large format cameras, where bellows extensions are almost unlimited. The size of the image circle that produces satisfactory image quality is smallest when the lens is focused at infinity.

Image distortion—Refers to anything in the image that does not appear the way it looked to our eyes. Most image distortions are not created by the lens or camera but by the way the camera or lens was used. Image distortions can also be created artificially while the image is made or afterward.

Image perspective—The size relationship between subjects at different distances as recorded in the camera. Perspective in a photograph is determined by the camera position, the distance between the lens and the closest subject.

Image plane flatness—When the image is recorded on film, maximum sharpness over the entire image area is achieved only if the film surface in the camera is sufficiently flat. You cannot reap the benefits of the highest quality lens if the image plane is not flat.Film flatness in any camera depends mainly on the precision in the film plane design and pressure plate. It is easier to accomplish good film flatness in a smaller format (35mm or APS system), but variations exist even in these film formats.

Image sharpness—A visual perception of the amount of detail that is recorded or recognized on the film or the final image. The sharpness of a photographic image is, however, not so much determined by the amount of detail that is visible but the edge sharpness within the subject details.

Image stabilizer—An arrangement built into some telephoto lenses to suppress camera motion created in handheld photography and thereby produce sharper images. Also allows for use of longer shutter speeds with handheld photography.

Incident meter—An exposure meter that measures the light that falls on the subject that we are photographing. The reading is unaffected by the brightness or color of the subject.

Infrared photography—Beyond the red wavelength lies infrared radiation, which is not visible to the eye but can be recorded photographically on special infrared emulsions. Infrared radiation has important applications in scientific photography and exciting possibilities for the photographer seeking to produce images with unusual colors or tonal renditions on black and white film.

Interchangeable film magazines—In medium format cameras, the film may be loaded into a separate, removable film magazine. This allows changing from one type of film to another in the middle of the roll of film.

Internal Focusing—An optical lens design where the distance setting of the lens is accomplished optically, rather than by physically moving the entire lens.

Internegative—A color print from an original color transparency is usually produced by first making a color negative from the transparency. This negative is called an internegative. The color print is then made from this negative.

ISO—International standard to indicate the sensitivity of a film. A higher number means a film with a higher sensitivity, a faster film. Identical to ASA numbers.

Large format—Film sizes larger than the medium format, usually 4" x 5" or 8" x 10" recorded on sheet film.

Lens coating—A coating over a glass surface to reduce the amount of light that is reflected off the glass surface. Invented in 1935 as a single layer coating that reduced reflected light from about 5% to 1%. Number of layers was increased over the years and today all quality lenses are multicoated. This can reduce reflections to less than 0.5%. In multicoating, each layer has a different thickness based on the wavelength of the different colors of light.

Lens elements—A single lens within the camera lens. These lens elements may be single components in the lens or they may be cemented together with one or two other lens elements to form a lens component.

Lens plane—The position of the lens in relation to the image plane. The two must normally be parallel to each other. On large format and some medium format cameras, one can be shifted or tilted in relation to the other to increase the range of sharpness or eliminate the need for tilting the camera. There are also lenses where shift and tilt are built-in features.

Lens shade—An accessory or part of the lens that eliminates unwanted light from reaching the lens and causing flare. A lens shade must be used even with multicoated lenses as the two serve different purposes. The lens shade reduces flare by eliminating the unwanted light, the multi-coating does the same but with the light needed to form the image on the film.

Loupe—A magnifying glass that is used to check the sharpness and quality of a negative or transparency. Such a loupe may show the entire negative area but in such a case is undoubtedly of a lower magnification. For examining image sharpness, a loupe with a higher magnification (8x or 10x) is preferable, even if it does not cover the entire negative area.

Low-dispersion glass—The various lens elements within a photographic lens are made from different types of glass with the main difference being the refractive index of the glass. The refractive index refers to the angle at which the light is bent when it enters and leaves the glass. Low dispersion glass has an uncommon refractive index that may be helpful or necessary in designing certain lens types.

Macro lens—Usually a lens where the focusing control can be set to much closer distances than on an "ordinary" lens. Such a lens may eliminate the need for close-up accessories. The term "macro" may also refer simply to the fact that such a lens is designed optically to produce the best image quality at close distances.

Manual stop-down control—For manually stopping down a lens aperture on an SLR camera in order to see the image on the focusing screen at the different f-stops instead of just at the normally set maximum aperture.

Medium format—Film format larger than 35mm but not as large as 4" x 5". Combines some of the benefits and advantages of each. The most popular medium formats are 4.5cm x 6cm, 6cm x 6cm, 6cm x 7cm and 6cm x 8cm. Medium format images are usually recorded on 120 or 220 roll film.

Memory card—The device that stores the image in a digital camera. Equivalent to film in an ordinary camera.

Mirror lens—Some designers have found it advantageous to combine lens elements with a mirror when designing long telephoto lenses. Mirror lenses have one aperture only, usually f/8 or f/11, or perhaps f/5.6. Depth of field control is therefore not possible.

Mirror lockup—A feature found in some SLR cameras that allows moving the mirror manually from the viewing to the taking position before the image is made. This reduces the danger of the mirror motion producing unsharpness on the film.

Monopod—A single support post for the camera that, at shorter shutter speeds, can serve the same purpose as a tripod. A monopod is more convenient for carrying and faster to use. A monopod can be equipped with the same heads used on tripods.

Motordriven film advance—A camera where the film is advanced to the next picture by means of a motordrive. The motor can be built into the camera or can be an accessory motor winder that can be attached to the camera. Motordriven film advance may allow faster shooting. Being able to keep the eye in the viewfinder of the camera, however, is the major benefit of a motor winder in most photography.

MTF diagrams—The best and most widely used method to show the sharpness of a lens. With the Modulation Transfer Factor usually on a vertical axis, the curves of different spatial frequencies indicate the image quality over the entire image area. This is based on the fact that perceived image sharpness is not so much based on resolution as on the edge sharpness. Some manufacturers publish these curves based on what the computer says the lens should produce, others are based on the performance of the actual lens as made and sold. The latter is more meaningful.

Multi-coating—Used on all high quality lenses today. The coating reduces the amount of light reflected on the glass surface and thus reduces flare and increases the contrast and color saturation.

Panoramic format—An image format that is at least twice as long in one dimension as in the other. Such images can be produced in APS and special panoramic medium format and 35mm cameras. Panoramic images can be produced in some other cameras with masks or special magazines. The final image can also be changed into a panoramic by cropping.

PC card—A removable card that stores a larger number of data (pictures) in a digital camera. The image on the card can be viewed on a computer or TV screen or can be made into a print. In a way, the card is what a roll of film is in a film camera.

PC lens—A lens design with shift control built into the lens barrel to eliminate the need for tilting the camera. Such a lens may also have built-in tilt control.

Perspective control—A feature built into special lenses, teleconverters or cameras that allows moving either the lens or the film in relation to the other. Eliminates or reduces the need for tilting the camera, which would result in slanted lines. Helpful or necessary for architectural work.

Photomicroscopy—The technique of taking pictures through a microscope.

Pincushion distortion—Lens distortion in which straight lines at the edge of the frame appear to bend outward toward the corners.

Pixels—("PIX" for picture, and "EL" for element) Microscopic sensing points on the chip in digital cameras that read the light and convert it into digital signals. The higher the number of pixels, the better the resolution in the image. Three megapixels, for instance, means that the sensor has three million pixels.

Plane of focus—The plane at which the lens is focused.

Principle plane—Every lens has a front and rear principle plane, usually known to the lens designer only but sometimes shown on lens specification sheets. The focal length of a lens is measured from the rear principle plane.

Prism viewfinders—A viewfinder that allows viewing and focusing the image on an SLR focusing screen from different angles, usually from 90° eye level or from 45°.

Projection lens—Lens used on a projector to enlarge a slide and project it onto a screen. The image on the screen can only be as good as the projection lens and the projector's illuminating system. The projection lens can be a fixed focal length or a zoom lens. The latter is convenient when the projector is used in different locations. If you decide on a zoom lens, check its image quality carefully at all focal lengths.

Proxar lens—Another name for a close-up lens that is mounted in front of the camera lens for photographing at closer distances.

Pupil, entrance and exit—Characteristics resulting from a lens design. Usually known to the designer only. Size of entrance pupil determines lens aperture.

Rangefinder, split image—An optical arrangement with two images used for focusing a lens. Can be part of an optical viewfinder or of a focusing screen.

Rear nodal point—The point where the rear principal plane intersects the optical axis of a lens. *See also* Princilpe plane.

Reflected meter—An exposure meter that measures the light reflected from the subject we are photographing. Exposure meters built into cameras are of the reflected type. The meter reading is affected by the brightness of the subject.

Relative Illuminance—With every lens, the corners of the image receive somewhat less light than the center. The difference between illumination at the center of the image and at the edges is called the relative illuminance. Some lens manufacturers publish the data for relative illuminance. Like MTF diagrams, the illuminance is shown with the lens aperture wide open and somewhat closed down and also with the center of the image with full 1.0 or 100 illumination at the left and the distances from the center indicated on the horizontal axis.

Resolution—(1) The number of lines per millimeter a lens is capable of reproducing as separate lines.

Retrofocus—A wide-angle lens design with a very long back focus (distance from rear element to image plane) that is necessary on SLR cameras where the mirror needs the space to move up and down. Wide-angle lenses on SLR cameras are of the retrofocus type. The other wide-angle design, the optically true wide-angle type, is used on large format and special medium format cameras.

Reversing lens—Lens that can be mounted on the camera in a reversed fashion, with the rear toward the subject and the front toward the image plane. A lens used in this position can provide better quality in close-up photography, but only when the magnifications are larger than 1:1.

Shift—Shift control allows either the lens or the image plane to move up, down, or sideways while remaining parallel to each other. This application is used mainly in product and architectural photography to maintain parallel vertical or horizontal lines.

Shutter—Device that is open a specific length of time to let light go to the image plane. The shutter can be in the camera, usually in front of the image plane (focal plane type) or in the lens.

Shutter speed—The length of time that the shutter in the camera or lens is open to let light travel to the image plane to make the exposure.

Slanted verticals—Slanted verticals are caused by tilting the camera, which places the image plane at an angle to the subject. Instead of tilting the camera upward or downward, you can shift the image plane or the lens plane and cover the same area while keeping the image plane parallel to the subject. As long as the image plane is parallel to the subject, the verticals will be straight and parallel in the picture.

SLR camera—A camera type with a mirror that projects the image to the focusing screen for viewing. The mirror moves out of the way for taking the image. SLR (single lens reflex) cameras always show the image as it is recorded in the camera. The image can also be viewed at the chosen aperture setting if the camera has a manual stop down control.

Soft focus filter—Filter that can be attached to any focal length lens (as long as the filter is as large as the front diameter of the lens), allowing you to create soft focus images with standard, wide-angle, and telephoto lenses at a fraction of the cost of a soft focus lens.

Soft focus lens—Soft focus lenses, available for cameras in most image formats, produce an image that is haloed to give the image a luminous appearance. This effect is often desirable in portrait and fashion photography, and also in advertising images of beauty products, where the softened effect adds a more glamorous feeling to the image. The same effect can be created with soft focus filters.

Spherical aberration—Light rays that enter through the outer edges of a single lens element form an image at a different distance than the rays entering closer to the center of the lens. These rays must be brought together to form an image in a single plane. Spherical aberration affects the image quality across the entire image area, but can be reduced by closing the aperture.

Spot meter—An exposure meter that only measures a small area of the subject. A spot meter can be built into the camera or be a separate accessory. The area that is measured is clearly indicated on the focusing screen in the camera or in the viewfinder of an accessory spot meter.

Subject brightness—The amount of light reflected off a subject, which must be considered when taking reflected exposure meter readings, and when using automatic or dedicated flash.

Teleconverter—Lens design mounted between the camer and lens to increase the focal length of the lens. A 2x converter doubles the focal length of the lens, a 1.4x converter increases the focal length 1.4x.

Telephoto lens—A lens that has a focal length longer than the standard (50mm for 35mm, 80mm for the 6x6 medium format). Telephoto lenses are usually separated into short telephotos going up to about double the focal length of the standard and the longer types. A lens of the optically true telephoto design is physically shorter than its focal length. Most long camera lenses are of this design.

Tilt—As the name indicates, tilting refers to the tilting of either the lens or the image plane so the two are no longer parallel. This tilt motion increases the range of sharpness along one subject plane far beyond what the depth of field of the lens could do. Tilting has wide applications—from tabletop still life and product photography to outdoor fine art work.

T-numbers—Some lenses for professional motion picture cameras are engraved with aperture figures in T-numbers rather than in f-stop numbers. T-numbers are based on the actual amount of light that reaches the film, taking the light that is lost due to reflection on the lens surfaces and by absorption in the glass into consideration.

Transparency film—Records a positive image on the film, an image where the colors are the same as in reality, where black is recorded as black, and white as white. Such films are available for color and black & white photography.

Tripod—A camera accessory to support the camera for steadier operation than handheld. Necessary or recommended with longer shutter speeds and/or longer focal length lenses.

TTL metering—TTL stands for "Through The Lens." It is usually used in connection with a light-metering system that measures the light through the camera lens or a dedicated flash system that measures the flash reflected from the subject through the lens.

Ultraviolet photography—In ultraviolet photography, the subject is illuminated with ultraviolet (UV) light and photographed through a filter that absorbs all the visible light. UV photography is used mainly in the scientific field for the examination of altered documents, engravings, tapestries, paintings, sculptures, etc.

Viewfinder—The camera component that is used to view the subject (an optical viewfinder) or lets you view the image of the subject on the focusing screen (as on a single reflex camera).

Vignetting—Darkening at the corners and sides of an image. This can be done artificially to emphasize the main subject (common in portraiture). It can also be caused by a filter or lens shade that is too small for the focal length and/or diameter of the lens, or by shifting a lens beyond its covering power. Some wide-angle lenses (especially extreme wide-angle lenses) also exhibit a darkening on the corners.

Vignetting, mount—A vignetting of light rays that enter a lens at a steep angle. Cause by the mechanical design of the lens barrel, theis creates a darkening of the image at the corners.

Wide-angle distortion—Wide-angle distortion refers to three-dimensional subjects being recorded distorted (elongated) at the edges or corners of an image, especially when made with wide-angle lenses on any camera. Mainly caused because the image plane is flat. Definitely not a fault in the wide-angle lens design.

Wide-angle lens—A lens with a focal length shorter than the standard. There are two optically different wide-angle lens designs. An optically true wide-angle lens must be close to the image plane and can therefore not be used on SLR cameras. A retrofocus wide-angle lens is necessary for this type of camera.

Zone System—A subject evaluation and metering system where the different subject brightness values from white to black are broken down into ten Zones. Black & white film developing times are adjusted to produce a black & white negative of normal contrast (printable on #2 paper), no matter what the contrast range of the original subject might have been.

Zoom effects—Produced by changing the focal length (zooming) while the image is recorded in the camera. Zooming changes the image size while the subject or scene is recorded producing a streaking effect on the film.

Zoom lens—A lens design where the focal length can be changed within a certain range by moving some of the lens elements. The range of focal lengths is called the zoom range. True zoom lenses stay in focus when the focal length is changed, some require refocusing

INDEX

· ·

Other Books from
Amherst Media™

Lighting for People Photography, 2nd Edition
Stephen Crain

The up-to-date guide to lighting. Includes: set-ups, equipment information, strobe and natural lighting, and much more! Features diagrams, illustrations, and exercises for practicing the techniques discussed in each chapter. $29.95 list, 8½x11, 120p, 80 b&w and color photos, glossary, index, order no. 1296.

Big Bucks Selling Your Photography, 2nd Edition
Cliff Hollenbeck

A completly updated photo business package. Includes starting up, getting pricing, creating successful portfolios and using the internet as a tool! Features setting financial, marketing and creative goals. Organize your business planning, bookkeeping, and taxes. $17.95 list, 8½, 128p, 30 photos, b&w, order no. 1177.

Outdoor and Location Portrait Photography
Jeff Smith

Learn how to work with natural light, select locations, and make clients look their best. Step-by-step discussions and helpful illustrations teach you the techniques you need to shoot outdoor portraits like a pro! $29.95 list, 8½x11, 128p, 60+ b&w and color photos, index, order no. 1632.

Make Money with Your Camera
David Neil Arndt

Learn everything you need to know in order to make money in photography! David Arndt shows how to take highly marketable pictures, then promote, price and sell them. Includes all major fields of photography. $29.95 list, 8½x11, 120p, 100 b&w photos, index, order no. 1639.

Wedding Photography:
Creative Techniques for Lighting and Posing, 2nd Edition
Rick Ferro

Creative techniques for lighting and posing wedding portraits that will set your work apart from the competition. Covers every phase of wedding photography. $29.95 list, 8½x11, 128p, full color photos, index, order no. 1649.

Professional Secrets of Advertising Photography
Paul Markow

No-nonsense information for those interested in the business of advertising photography. Includes: how to catch the attention of art directors, make the best bid, and produce the high-quality images your clients demand. $29.95 list, 8½x11, 128p, 80 photos, index, order no. 1638.

Lighting Techniques for Photographers
Norman Kerr

This book teaches you to predict the effects of light in the final image. It covers the interplay of light qualities, as well as color compensation and manipulation of light and shadow. $29.95 list, 8½x11, 120p, 150+ color and b&w photos, index, order no. 1564.

Infrared Photography Handbook
Laurie White

Covers black and white infrared photography: focus, lenses, film loading, film speed rating, batch testing, paper stocks, and filters. Black & white photos illustrate how IR film reacts. $29.95 list, 8½x11, 104p, 50 b&w photos, charts & diagrams, order no. 1419.

Computer Photography Handbook
Rob Sheppard

Learn to make the most of your photographs using computer technology! From creating images with digital cameras, to scanning prints and negatives, to manipulating images, you'll learn all the basics of digital imaging. $29.95 list, 8½x11, 128p, 150+ photos, index, order no. 1560.

Creating World-Class Photography
Ernst Wildi

Learn how any photographer can create technically flawless photos. Features techniques for eliminating technical flaws in all types of photos—from portraits to landscapes. Includes the Zone System, digital imaging, and much more. $29.95 list, 8½x11, 128p, 120 color photos, index, order no. 1718.

The Beginner's Guide to Pinhole Photography

Jim Shull

Take pictures with a camera you make from stuff you have around the house. Develop and print the results at home! Pinhole photography is fun, inexpensive, educational and challenging. $17.95 list, 8½x11, 80p, 55 photos, charts & diagrams, order no. 1578.

The Art of Portrait Photography

Michael Grecco

Michael Grecco reveals the secrets behind his dramatic portraits which have appeared in magazines such as *Rolling Stone* and *Entertainment Weekly*. Includes: lighting, posing, creative development, and more! $29.95 list, 8½x11, 128p, 60 photos, order no. 1651.

Telephoto Lens Photography

Rob Sheppard

A complete guide for telephoto lenses. Shows you how to take great wildlife photos, portraits, sports and action shots, travel pics, and much more! Features over 100 photographic examples. $17.95 list, 8½x11, 112p, b&w and color photos, index, glossary, appendices, order no. 1606.

Essential Skills for Nature Photography

Cub Kahn

Learn all the skills you need to capture landscapes, animals, flowers and the entire natural world on film. Includes: selecting equipment, choosing locations, evaluating compositions, filters, and much more! $29.95 list, 8½x11, 128p, 60 photos, order no. 1652.

Special Effects Photography Handbook

Elinor Stecker-Orel

Create magic on film with special effects! Little or no additional equipment required, use things you probably have around the house. Step-by-step instructions guide you through each effect. $29.95 list, 8½x11, 112p, 80+ color and b&w photos, index, glossary, order no. 1614.

Photographer's Guide to Polaroid Transfer

Christopher Grey

Step-by-step instructions make it easy to master Polaroid transfer and emulsion lift-off techniques and add new dimensions to your photographic imaging. Fully illustrated every step of the way to ensure good results the very first time! $29.95 list, 8½x11, 128p, 50 photos, order no. 1653.

McBroom's Camera Bluebook, *6th Edition*

Mike McBroom

Comprehensive and fully illustrated, with price information on: 35mm, digital, APS, underwater, medium & large format cameras, exposure meters, strobes and accessories. Pricing info based on equipment condition. A must for any camera buyer, dealer, or collector! $29.95 list, 8½x11, 336p, 275+ photos, order no. 1553.

Black & White Landscape Photography

John Collett and David Collett

Master the art of b&w landscape photography. Includes: selecting equipment (cameras, lenses, filters, etc.) for landscape photography, shooting in the field, using the Zone System, and printing your images for professional results. $29.95 list, 8½x11, 128p, 80 b&w photos, order no. 1654.

Family Portrait Photography

Helen Boursier

Learn from professionals how to operate a successful portrait studio. Includes: marketing family portraits, advertising, posing, lighting, and selection of equipment. Includes images from a variety of top portrait shooters. $29.95 list, 8½x11, 120p, 123 photos, index, order no. 1629.

Wedding Photojournalism

Andy Marcus

Create dramatic unposed wedding portraits. Working through the wedding you'll learn where to be, what to look for and how to capture it on film. A hot technique for contemporary wedding albums! $29.95 list, 8½x11, 128p, b&w, over 50 photos, order no. 1656.

The Art of Infrared Photography, *4th Edition*

Joe Paduano

A practical guide to the art of infrared photography. Tells what to expect and how to control results. Includes: anticipating effects, color infrared, digital infrared, using filters, focusing, developing, printing, handcoloring, toning, and more! $29.95 list, 8½x11, 112p, 70 photos, order no. 1052

Studio Portrait Photography of Children and Babies

Marilyn Sholin

Work with the youngest portrait clients to create images that will be treasured for years. Includes tips for working with kids at every developmental stage, from infant to pre-schooler. Features: lighting, posing and much more! $29.95 list, 8½x11, 128p, 60 photos, order no. 1657.

Photo Retouching with Adobe® Photoshop®

Gwen Lute

Designed for photographers, this manual teaches every phase of the process, from scanning to final output. Learn to restore damaged photos, correct imperfections, create realistic composite images and correct for dazzling color. $29.95 list, 8½x11, 120p, 60+ photos, order no. 1660.

Creative Lighting Techniques for Studio Photographers

Dave Montizambert

Master studio lighting and gain complete creative control over your images. Whether you are shooting portraits, cars, table-top or any other subject, Dave Montizambert teaches you the skills you need to confidently create with light. $29.95 list, 8½x11, 120p, 80+ photos, order no. 1666.

Macro and Close-up Photography Handbook

Stan Sholik

Learn to get close and capture breathtaking images of small subjects – flowers, stamps, jewelry, insects, etc. Designed with the 35mm shooter in mind, this is a comprehensive manual full of step-by-step techniques. $29.95 list, 8½x11, 120p, 80 photos, order no. 1686.

Composition Techniques from a Master Photographer

Ernst Wildi

Composition can make the difference between dull and dazzling. Master photographer Ernst Wildi teaches you his techniques for evaluating subjects and composing powerful images in this beautiful full color book. $29.95 list, 8½x11, 128p, 100+ full color photos order no. 1685.

Dramatic Black & White Photography:

Shooting and Darkroom Techniques

J.D. Hayward

Create dramatic fimages and portraits with the master techniques in this book. From outstanding lighting techniques to top-notch, creative darkroom work, this book takes b&w to the next level! $29.95 list, 8½x11, 128p, order no. 1687.

Photographing Your Artwork

Russell Hart

A step-by-step guide for taking high-quality slides of artwork for submission to galleries, magazines, grant committees, etc. Learn the best photographic techniques to make your artwork (be it 2D or 3D) look its very best! $29.95 list, 8½x11, 128p, 80 b&w photos, order no. 1688.

How to Buy and Sell Used Cameras

David Neil Arndt

Learn the skills you need to evaluate the cosmetic and mechanical condition of used cameras, and buy or sell them for the best price possible. Also learn the best places to buy/sell and how to find the equipment you want. $19.95 list, 8½x11, 112p, b&w, 60 photos, order no. 1703.

Medium Format Cameras: User's Guide to Buying and Shooting

Peter Williams

An in-depth introduction to medium format cameras and the photographic possiblities they offer. This book is geared toward intermediate to professional photographers who feel limited by the 35mm format. $19.95 list, 8½x11, 112p, 50 photos, order no. 1711.